ZAHA HADID RECENT PROJECT

Edited by Yukio Futagawa

Copyright © 2010 A.D.A. EDITA Tokyo Co., Ltd.
3-12-14 Sendagaya, Shibuya-ku, Tokyo 151-0051, Japan
All rights reserved. No part of this publication may be reproduced,
stored in a retrieval system, or transmitted,
in any form or by any means, electronic, mechanical,
photocopying, recording, or otherwise,
without permission in writing from the publisher.

Copyright of photographs except as noted
© 2010 GA photographers
Copyright of drawings and renderings
© 2010 Zaha Hadid Architects

Printed and bound in Japan

ISBN 978-4-87140-669-7 C1052

ZAHA HADID
RECENT PROJECT

A.D.A. EDITA Tokyo

RECENT PROJECT

HADID

An Email Dialogue, July, 2010
Zaha Hadid

GA: Since the publication of the special issue in 2007 *(GA DOCUMENT 99—Special Issue Zaha Hadid)*, has your work changed in any way? Has your production process or office structure changed, for example by introducing new professional skills, methods or technologies; in the steps taken when your projects are being developed; in the structure of or number of people in your project teams; or in the way team members communicate with Zaha and Patrik Schumacher?

Zaha Hadid (ZH): Since the last special issue in 2007, Zaha Hadid Architects has grown by over 50%. We are now 400 people strong. We have recently completed the MAXXI (National Museum of XXI Century Arts) and Guangzhou Opera House and currently have 16 further buildings under construction around the world, with many other projects on the drawing board.

GA: Are there any new concepts (architectural, social, ecological, etc.) that sprung from your recent projects?
How do you see the shifts in the architecture world that occurred during the last three years and do you feel responsible to any societies or rules in today's architecture?

ZH: In 2008 we launched the concept of Parametricism as new paradigm and style for architecture. Parametricism assumes that all element of architecture are parametrically malleable and thus able to adapt to each other and to the environment via scripted correlations. This implies an overall intensification of relations both internally within the buildings as well externally with the context. We believe that Parametricism is a credible candidate to become the first unified, epochal style after modernism. The conceptual and formal repertoire of Parametricism is geared up to deliver architectural innovations that are well adapted to the challenges of contemporary society: post-fordist network society.

GA: Have you found any new talents (young architects, designers, engineers) in architecture recently?

ZH: There has never been a shortage of talent. What is exciting now is that the period of confusion and searching that was engendered by the crisis of modernism is finally drawing to a close. The new paradigm/style of Parametricism is gaining nearly universal following in the new generation. There develops a truly collective research culture where many contributions and innovations are directly relevant to each other, feeding into each other along the lines of a unified design research programme. Talents flourish in this new exciting global movement.

GA: Besides architecture, are there any particular things or phenomena in such fields as art, fashion, literature, science or politics that interest you?

ZH: Science has been the most fruitful inspiration, in particular the whole paradigm of complexity and self-organisation etc. that has set physics and biology onto a new path. These are fruitful analogies to be drawn. Frei Otto's paradigm of physical form-finding was part of this revolution in science.

GA: Tell us about the product design of your recent works such as furniture.

ZH: We have been designing a very interesting variety of products: sofas, tables, chandeliers, jewelry, shoes, cars, and we would like to go into fashion soon. The design disciplines are in fact a single discourse and we feel at home with all design tasks.

GA: How would you describe the evolution of your architecture in respect to the completion of the MAXXI?

ZH: In the last 10 years we have worked to achieve the ultimate in fluid space and dealing with complexity. It started off as juxtaposition and superposition, then moved on to planar and volumes. This developed further when we began working with very large programmes—we thought to move away from the podium slab or podium tower, and to think of a landmass like a landscape. A landscape that

GA：2007年の特集号（『GA DOCUMENT 99』Special Issue Zaha Hadid）以来，仕事に何か変化はありましたか？ 制作プロセスや事務所の構成が変わったり，例えば新たな専門技術・メソッド・手法などを導入したりといったことや，プロジェクトの進行段階やプロジェクト・チームの体制や構成員数，メンバー達と貴方やパトリック・シューマッハの間のコミュニケーションなどに変化はありましたか？

ザハ・ハディド（ZH）：2007年の特集号以来，ザハ・ハディド・アーキテクツは50％の成長を遂げました。現在の規模は400人強。最近「MAXXI」（国立21世紀美術館）と「広州オペラハウス」が完成し，建設中の建物が世界中に16件あり，計画段階のプロジェクトも多数抱えています。

GA：最近のプロジェクトから生まれた新たなコンセプト（建築的・社会的・エコロジカル等）はありますか？ また，ここ3年間の建築の世界の動向をどうご覧になりますか？ 現在の建築のルールや社会に対して何か責任を感じられることはありますか？

ZH：2008年に，建築の新たなパラダイムおよび様式として，「パラメトリシズム」の概念を打ち出しました。パラメトリシズムにおいては，すべての建築要素にはパラメトリックな適応性があり，つまり処方された相関関係を通じて互いに，そして環境と順応しあうことが出来るという前提があります。それが示唆するのは建物の内部における関係性や外部におけるコンテクストとの関係性の全体的な強化です。私たちはパラメトリシズムが，モダニズム後の最初の統合的かつ画期的な様式に充分なり得ると信じています。パラメトリシズムの概念および形式レパートリーが，ポスト＝フォード式ネットワーク社会という現代社会の課題により適した革新を建築にもたらすべく体制を整えています。

GA：最近，建築において面白いと思った新たな才能（若手の建築家，デザイナー，技術者）はいますか？

ZH：今まで才能ある人材の不足を感じたことはありません。今，面白いのは，モダニズムの危機から生じた混乱と手探りの時代がようやく終わりを迎えようとしていること。パラメトリシズムという新たなパラダイム／様式が次世代の支持をほぼ世界中で受けているのです。そこには本当の意味で共同研究の文化が育まれており，互いに直接関わるような多くの貢献や改革がなされ，統一されたデザイン研究プログラムに沿ってそれぞれの糧となっている。そのようなグローバルな動きの中で才能が開花しており，なかなか楽しみです。

GA：建築以外で，アート，ファッション，文学，サイエンス，政治といった他の分野で興味を持たれている物や現象はありますか？

ZH：サイエンス，特に物理学や生物学に新たな道を開いた複雑性や自己組織化といった一連のパラダイム全体は，最も実りの多いインスピレーションを与えてくれます。そこからは有益なことをたくさん学べるはずです。フライ・オットーの物理学的な形状発見のパラダイムは，こういったサイエンスにおける変革の一端だと思います。

GA：家具など最近手がけられた作品のプロダクト・デザインについて教えて下さい。

ZH：ソファー，テーブル，シャンデリア，ジュエリー，靴，自動車といったバラエティに富んださまざまなプロダクトのデザインを手がけていて，近いうちにファッションの分野にも参入したいと思っています。デザインの領域にディスコースは一つしかないので，どのようなデザインの仕事においても違和感を感じたりすることはありません。

GA：「MAXXI」の完成を受けて，ご自分の建築の進化についてどのようにお考えですか？

ZH：ここ10年来，私たちは流体空間を極めるべく複雑性と関わってきました。最初は並列や重層，そして次第に平面やヴォリュームへと移行し，非常に大きなプログラムを手がけるようになり，さらに進化しました。基壇スラブや基壇タワーから離れ，ランドスケープのような陸塊を考えるようになったのです。ランド

meets the ground without interrupting the programme and connections: ultimate mobility and ultimate fluidity.

I think the layering was always there. A lot of this work was based on drawing research—looking at abstraction, geology and archaeology. We then began to look at organic morphology—cells and biology—but always through geometry. I would say it became more extreme—because it had to accommodate so many different needs in one solution. This work was obviously non-Euclidean geometry. People ask why there are no straight lines in the work—and that's because life is not made in a grid. It could be interesting at times to consider a grid imposed on a terrain, but if you think of natural landscapes—they are not even grids. People go to these natural places and think it's very relaxing. I think that one can do that in architecture. This is particularly appropriate for civic buildings because it has to do with movement; how you move from one space to another, how you understand a building. Museums do not have to be a linear sequence of rooms like they used to be in previous centuries. Museums should encourage different adjacencies.

These days, it is important to have this variety of space—allowing curators to make so many different interpretations of space when designing exhibitions. It's not only a question of how you exhibit the art, but also about how, through complexity, curators can interpret different leads and different connections. This ability to see different perspectives and different relationships all at the same time is very important.

This fluid movement through space is very critical. In the MAXXI, there is an applied formalism. Lines drift in unison until they bifurcate, intersect or turn the corner of the L-shaped site to generate interior and exterior spaces. But the movement through the building continues up and around the museum on the ramps and bridges—defining a series of galleries, but at the same time, also establishing one single infinite space that keeps drawing you forward—without a real point of beginning or termination. Intimate spaces between walls open out onto many levels and vistas—but the building always gives you clues how to move forward.

I met 16 year-old boy at the MAXXI opening earlier this year. He told me walking through the museum was like riding on a boat in a river—and seeing how the fluidity of the water naturally erodes the riverside embankments. This was fascinating because our original idea for the MAXXI was actually like a river delta. The major streams become the galleries and the minor streams become the ramps and bridges that connect them. I found it very touching that someone not trained in the architecture profession had such an accurate reading of the space.

GA: What are your visions on the future of architectural activities, for example over the next decade? Have you set yourself any goals you wish to achieve? Have you discovered any particular strategies as you worked in recently burgeoning regions such as China and the Middle East lately, such as, for instance, non-European formal architecture being effective in certain places?

ZH: We are trying to expand and universalize our approach to architecture in collaboration and competition with the upcoming generation of architects. We believe that architecture today in terms of concepts and principles exists as world architecture. This includes the capacity for local adaptations on the basis of inherent social and environmental sensitivity of our principles.

There is a definite connection between certain digital work we are doing now and the patterning of Islamic art and architecture. It is the mathematics of the Arab world and I am fascinated by—the mix of logic and abstract. In our office we are very interested in the concepts of pixilation and geometry—which has a connect to the Islamic art traditions and sciences in terms of algebra, geometry and mathematics.

Traditional Chinese art, architecture and garden design was important in the development of my early work and China has become one of the most exciting arenas for the advancement and realization of our architecture. I am enthusiastic about China's future contribution to world architecture and certainly hope to continue my involvement. There is an obvious enthusiasm, ambition and energy in the upcoming generation of Chinese architects. This new generation seems to find some inspiration in my work. I suspect these architects sense the influence of China's architectural traditions on my own work, or perhaps it is that my style demands a degree of commitment and optimism that one only finds in few places and periods, like China today, where the future offers such possibilities.

スケープが，さまざまな繋がりやプログラムを妨げることなく，大地に接する。それが究極のモビリティであり究極の流動性なのです。

　レイヤーという要素がいつでもそこにあったと思っています。「MAXXI」ではドローイングによるスタディに基づき，抽象化，地質学，考古学について考察を重ねました。そこから細胞や生物学といった有機的な形態について考えるようになりましたが，常に幾何学を念頭に置いていました。かなり極端なところまで行ったと思いますが，それはあまりに多くのニーズを一つの解の中に収めなければならなかったからです。この作品は明らかに非ユークリッド幾何学です。なぜ直線が無いのだとよく訊かれるのですが，生命はグリッドに沿ってつくられるものではありませんからね。時には地形に課されたグリッドを考えるのも面白いだろうとは思いますが，自然のランドスケープを見てみれば，それは均等なグリッドにはなっていないわけです。人はそういった場所に行って自然を感じたりリラックスしたりする。私はそれを建築でやることは可能だと思っています。特に，ある空間から別の空間への動き方，建物についての解釈の仕方といった，動きが関係してくるような公共建築には向いていると思います。美術館は，これまで何世紀もの間そうであったような，直線状の部屋の配列である必要はない。美術館はもっといろいろな異なった配列を促すべきです。

　近頃では，展覧会をデザインする際，キュレーターにとってありとあらゆる空間の解釈が許されるような，そんな空間の多様性が重要になってきています。単にいかに芸術を展示するかという問題ではなく，複雑性を通じてキュレーターがさまざまな手がかりや繋がりをどう解釈できるかという問題でもある。そのように同時に異なる視点や多くの関係性を持てる能力は，非常に大切なのです。

　空間を通じた流体運動はとても重要な意味を持っています。「MAXXI」には形式主義が応用されています。複数の線がユニゾンを奏で漂ううちに分岐し，交差したり，L字型の敷地の角を曲がったりして内部や外部空間をつくり出す。建物をつらぬく運動は上へ向かったり美術館の周りを廻ったりしてランプやブリッジへとさらに続き，一連の展示室を定義すると同時に訪れる人を前へと導いて行くたった一つの無限空間をつくり出し，そこには本当の始点や終点は存在しない。壁に挟まれた親密な空間が異なる階や眺望へと開いてゆく。それでいて建物は常に人を前へ前へと動かすためのヒントを与えてくれる。

　今年，「MAXXI」のオープニングで出会った16才の少年。彼が言うには，美術館の中を歩いているとボートで川下りをしているようだと。水の流れが自然と川岸の堤防を浸食するのを見ている感じがするのだそうです。これには驚くとともに嬉しく思いました。「MAXXI」の当初のイメージは実際，川の三角州だったからです。川の本流は展示室で，支流はそれらを繋ぐランプやブリッジ。建築を専門的に学んだことのない人が，これほど正確に空間を読み取ってくれたことにとても感動しました。

GA：建築活動の未来，例えばこれからの10年について，どのようなヴィジョンをお持ちですか？　何か目標を設定されていますか？　中国や中東といった興隆が著しい地域でお仕事をされる中で発見したストラテジー，例えば非ヨーロッパ的建築形式が有効である，といったことはありましたか？

ZH：私たちは次世代の建築家たちとのコラボレーションやコンペを通じて，建築に対するアプローチを拡張・一般化しようと試みているところです。現代の建築は概念や理念といった点で世界建築であると考えています。そこには私たちの理念に固有な社会的・環境的感受性に基づくローカルな適応を可能とする能力も含まれます。

　私たちが手がけているある種のデジタル作品とイスラム芸術と建築のデザイン様式の間には確かに関連性があると言えます。アラブ世界の数学，その論理と抽象の融合にはすっかり魅了されてしまいました。事務所内でも，イスラム芸術の伝統や代数学，幾何学や数学といった科学との関連で，ピクセレーションと幾何学の概念に非常に注目しています。

　中国の伝統的な芸術や建築，庭園設計は，私の初期作品に重要な影響を与えましたし，中国は私たちの建築の進化と実現にとって，最も刺激的な舞台の一つとなりました。私は世界建築に大いに貢献するであろうこれからの中国に期待を寄せるとともに，ずっと関わり続けて行きたいとも願っています。中国の若い世代の建築家たちは熱意と大志とエネルギーにあふれている。そしてその新しい世代が私の作品から何らかのインスピレーションを受けていることも確かです。そういった若い建築家たちは私自身の作品の中にある中国建築の伝統の影響を感じ取っていると思いますし，あるいは私のスタイルは，未来が多くの可能性を用意してくれている今日の中国のような，ある特殊な場所と時代にしか見ることのできない，一定レベルのコミットメントと楽観性を必要としているのかもしれません。

Contents　　目次

Interview　　インタヴュー
An Email Dialogue, July, 2010　6　2010年7月，eメールによる対話
Zaha Hadid　　ザハ・ハディド

MAXXI: National Museum of XXI Century Arts　12　MAXXI: 国立21世紀美術館
Rome, Italy　　イタリア，ローマ

Essay　　エッセイ
The Parametric City　42　パラメトリック・シティ
Patrik Schumacher　　パトリック・シューマッハ

Sheikh Zayed Bridge　44　シェイク・ザイード・ブリッジ
Abu Dhabi, United Arab Emirates　　アラブ首長国連邦，アブダビ

Glasgow Riverside Museum　48　グラスゴー・リバーサイド・ミュージアム
Glasgow, U.K.　　イギリス，グラスゴー

CMA CGM Tower　52　CMA CGMタワー
Marseille, France　　フランス，マルセイユ

London Aquatics Centre　56　ロンドン・アクアティック・センター
London, U.K.　　イギリス，ロンドン

Middle East Centre, St. Antony's College　64　オックスフォード大学 聖アントニー・カレッジ中東センター
Oxford, U.K.　　イギリス，オックスフォード

Heydar Aliyev Cultural Centre　70　ヘイダル・アリエフ文化センター
Baku, Azerbaijan　　アゼルバイジャン，バクー

Museum in Vilnius　78　ヴィリニュス美術館
Vilnius, Lithuania　　リトアニア，ヴィリニュス

Regium Waterfront　84　レギウム・ウォーターフロント
Reggio Calabria, Italy　　イタリア，レッジョ・カラブリア

New Beethoven Concert Hall　92　新ベートーヴェン・コンサート・ホール
Bonn, Germany　　ドイツ，ボン

King Abdullah II House of Culture & Art　100　アブドラII世文化芸術館
Amman, Jordan　　ヨルダン，アンマン

Stone Towers　106　ストーン・タワー
Cairo, Egypt　　エジプト，カイロ

CasArt	112	CasArt（カサブランカ芸術センター）
Casablanca, Morocco		モロッコ，カサブランカ
Sunrise Tower	120	サンライズ・タワー
Kuala Lumpur, Malaysia		マレーシア，クアラルンプール
Gui River Creative Zone	126	嬀河クリエイティブ・ゾーン
Beijing, China		中国，北京
The Circle at Zurich Airport	132	チューリッヒ空港「ザ・サークル」
Kloten, Switzerland		スイス，クローテン
Galaxy Soho	140	ギャラクシーSoHo
Beijing, China		中国，北京
Cairo Expo City	146	カイロ・エキスポ・シティ
Cairo, Egypt		エジプト，カイロ
Wangjing Soho	154	望京SoHo
Beijing, China		中国，北京
King Abdullah Petroleum Studies and Research Centre	158	アブドラ王石油調査研究センター
Riyadh, Saudi Arabia		サウジアラビア，リヤド
New Dance and Music Centre, The Hague	164	デン・ハーグ新ダンス・ミュージック・センター
The Hague, The Netherlands		オランダ，デン・ハーグ
Burnham Pavilion	170	バーナム・パヴィリオン
Chicago, U.S.A.		アメリカ，シカゴ
Exhibition 'Zaha Hadid and Suprematism'	174	「ザハ・ハディド／シュプレマティスム」展
Gmurzynska Gallery, Zurich, Switzerland		スイス，チューリッヒ，グムジンスカ・ギャラリー
Profile/List of Projects	178	プロフィール／プロジェクト・リスト

Cover
MAXXI: National Museum of XXI Century Arts
photo by Yukio Futagawa

Title pages
photo by Marco Grob (portrait of Zaha Hadid)

Translation
Lisa Tani: pp.6-9, p.43/
Yasuko Kikuchi: pp.13-15, p.47 (first paragraph), p.49, p.59/
Norihiko Tsuneishi: p.72, pp.98-99, p.105, p.114, p.135, p.140, p.168, pp.172-173/
Masayuki Harada: p.54, p.79, p.84, pp.110-111, p.121, p.125, p.152, p.157, p.176/
Shumpei Kitamura: p.47 (except for first paragraph), p.66, p.127, p.162

MAXXI: National Museum of XXI Century Arts

1998-2010 Rome, Italy Photos: Y. Futagawa (except as noted)

Architectural Concept and Urban Strategy:
Staging the Field of Possibilities
The MAXXI addresses the question of its urban context by maintaining a reference to the former army barracks. This is in no way an attempt at topological pastiche, but instead continues the low-level urban texture set against the higher level blocks on the surrounding sides of the site. In this way, the MAXXI is more like an 'urban graft', a second skin to the site. At times, it affiliates with the ground to become new ground, yet also ascends and coalesces to become massive where needed. The entire building has an urban character: prefiguring upon a directional route connecting the River to Via Guido Reni, the Centre encompasses both movement patterns existing and desired, contained within and outside. This vector defines the primary entry route into the building. By intertwining the circulation with the urban context, the building shares a public dimension with the city, overlapping tendril-like paths and open space. In addition to the circulatory relationship, the architectural elements are also geometrically aligned with the urban grids that join at the site. In thus partly deriving its orientation and physiognomy from the context, it further assimilates itself to the specific conditions of the site.

Space VS Object
Our proposal offers a quasi-urban field, a "world" to dive into rather than a building as signature object. The campus is organised and navigated on the basis of directional drifts and the distribution of densities rather than key points. This is indicative of the character of the MAXXI as a whole: porous, immersive, a field space. An inferred mass is subverted by vectors of circulation. The external as well as internal circulation follows the overall drift of the geometry. Vertical and oblique circulation elements are located at areas of confluence, interference and turbulence.

The move from object to field is critical in understanding the relationship the architecture will have to the content of the artwork it will house. Whilst this is further expounded by the contributions of our Gallery and Exhibitions experts, it is important here to state that the premise of the architectural design promotes a disinheriting of the 'object' orientated gallery space. Instead, the notion of a 'drift' takes on an embodied form. The drifting emerges, therefore, as both architectural motif, and also as a way to navigate experientially through the museum. It is an argument that, for art practice is well understood, but in architectural hegemony has remained alien. We take this opportunity, in the adventure of designing such a forward looking institution, to confront the material and conceptual dissonance evoked by art practice since the late 1960's. The path led away from the 'object' and its correlative sanctifying, towards fields of multi-

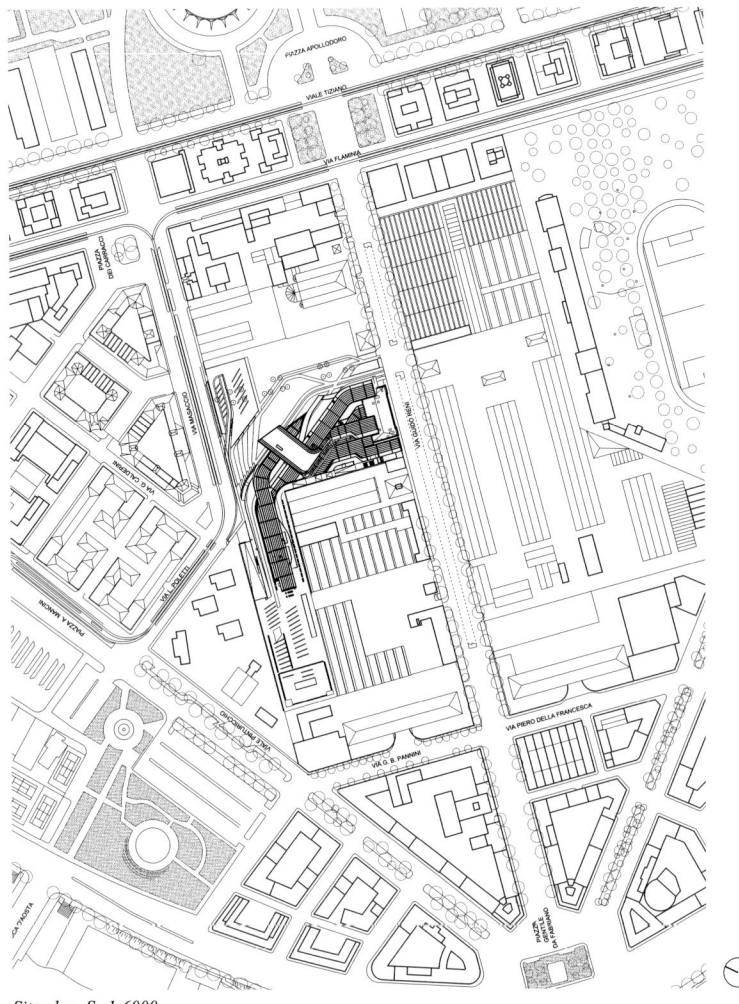

Site plan S=1:6000

ple associations that are anticipative of the necessity to change.

Institutional Catalyst
As such, it is deemed significant that in configuring the possible identity of this newly established institution (housing both Art and Architecture), with its aspiration towards the polyvalent density of the 21st century, conceptions of space and indeed temporality are reworked. Modernist Utopian space fuelled the white 'neutrality' of most 20th century museums. Now, this disposition must be challenged, not simply out of wilful negation, but by the necessity for architecture to continue its critical relationship with contemporary social and aesthetic categories. Since absolutism has been indefinitely suspended from current thought on the issue of art presentation, it is towards the idea of the 'maximising exhibition' that we gravitate. In this scenario, the MAXXI makes primary the manifold possibilities for the divergence in showing art and architecture as well as catalysing the discourse on its future. Again, the 'signature' aspect of an institution of this calibre is sublimated into a more pliable and porous organism that promotes several forms of identification at once.

Walls/Not-Walls:
Towards a Contemporary Spatiality
In architectural terms, this is most virulently executed by the figure of the 'wall'. Against the traditional coding of the 'wall' in the museum as the privileged and immutable vertical armature for the display of paintings, or delineating discrete spaces to construct 'order' and linear 'narrative', we have created a critique of it through its emancipation. The 'wall' becomes the versatile engine for the staging of exhibition effects. In its various guises—solid wall, projection screen, canvas, window to the city—the exhibition wall is the primary space-making device. By running extensively across the site, cursively and gestural, the lines traverse inside and out. Urban space is coincidental with gallery space, exchanging pavilion and court in a continuous oscillation under the same operation. And further deviations from the Classical composition of the wall emerge as incidents where the walls become floor, or twist to become ceiling, or are voided to become a large window looking out. By constantly changing dimension and geometry, they adapt themselves to whatever curatorial role is needed. By setting within the gallery spaces a series of potential partitions that hang from the ceiling ribs, a versatile exhibition system is created. Organisational and spatial invention are thus dealt with simultaneously amidst a rhythm found in the echo of the walls to the structural ribs in the ceiling that also filter the light in varying intensities.

Stage for Thought/Art as Drama
It is in this way that the architecture performs the 'staging' of art, with moveable elements that allow for the drama to change. 'Sets' can be constructed from the notional elements of the gallery spaces. These are attuned to the particularities of the exhibition in question, materialising or dematerialising accordingly.

The drift through the MAXXI is a trajectory through varied ambiences, filtered spectacles and differentiated luminosity. Whilst offering a new freedom in the curators' palette, this in turn digests and recomposes the experience of art spectatorship as liberated dialogue with artefact and environment.

〈建築的コンセプトと都市ストラテジー：可能性のフィールドを演出する〉
現代美術館は，以前ここにあった兵舎を連想させるような性格を維持することで，その都市文脈に対する問題提示を行う。これは，地形の寄せ集めをしようというのではなく，敷地を囲む高層の建物が並ぶ街区側に対抗させて，低層の都市構造を連続させるのである。この方法においては，美術館は"街の接ぎ木"，敷地の第2の皮膚のようなものである。時々，それは地とつながって新たな地を形成するが，必要な箇所では，立ち上がり合体してマッシブなものとなる。建物全体は都市的な性格をもつ。川とグヴィド・レーニ通りをつなぐ方向への道筋を想定しつつ，美術館は，既に存在するもの，望まれるもの，両方の通路パターンを，内，外に包含する。このベクトルは建物へ入る主要ルートを規定する。通路を都市文脈と撚り合わせることで，巻きひげのような通路やオープン・スペースが重層しながら，建物は都市の公共的なスケールを共有する。循環的な関係に加えて，建築的要素はまた，敷地に合流する都市グリッドと幾何学的に整列する。こうして，部分的にはコンテクストが備える方位や外形から生まれた建物は，敷地固有の状況にさらに深く同化する。

〈空間対物体〉
私たちの提案は，署名入りのオブジェクトとしての建物ではなく，疑似都市，そこに飛び込んでいけるような，ある"世界"を表現する。方向性をもって漂流し，点的な分布ではなく，密度の配分により空間は構成され，動いてゆく。

全体の性格を暗示するのは，多孔性，沈潜性，フィールド・スペースである。埋葬されたマッスは通路のベクトルによって転覆される。内部同様，外部の通路も幾何学の漂流に従う。垂直方向や斜めに進む通路は，合流，衝突，乱流ポイントに位置する。

オブジェクトからフィールドへの移行は，この建築が中に収めることになる芸術作品の内容との関係を理解する上で重要である。これは，ギャラリー／展覧会専門家の尽力によりさらに詳述されることになるが，この建築デザインの前提が，"オブジェクト"指向の展示室という遺産からの撤退を促進させるものであるとここで述べておくことは重要である。それに代わって"漂流"という概念が具体化された形のなかに取り入れられる。従って，漂流は，建築的主題にも，館内を経験しながら航行していく道筋にも出現する。それ

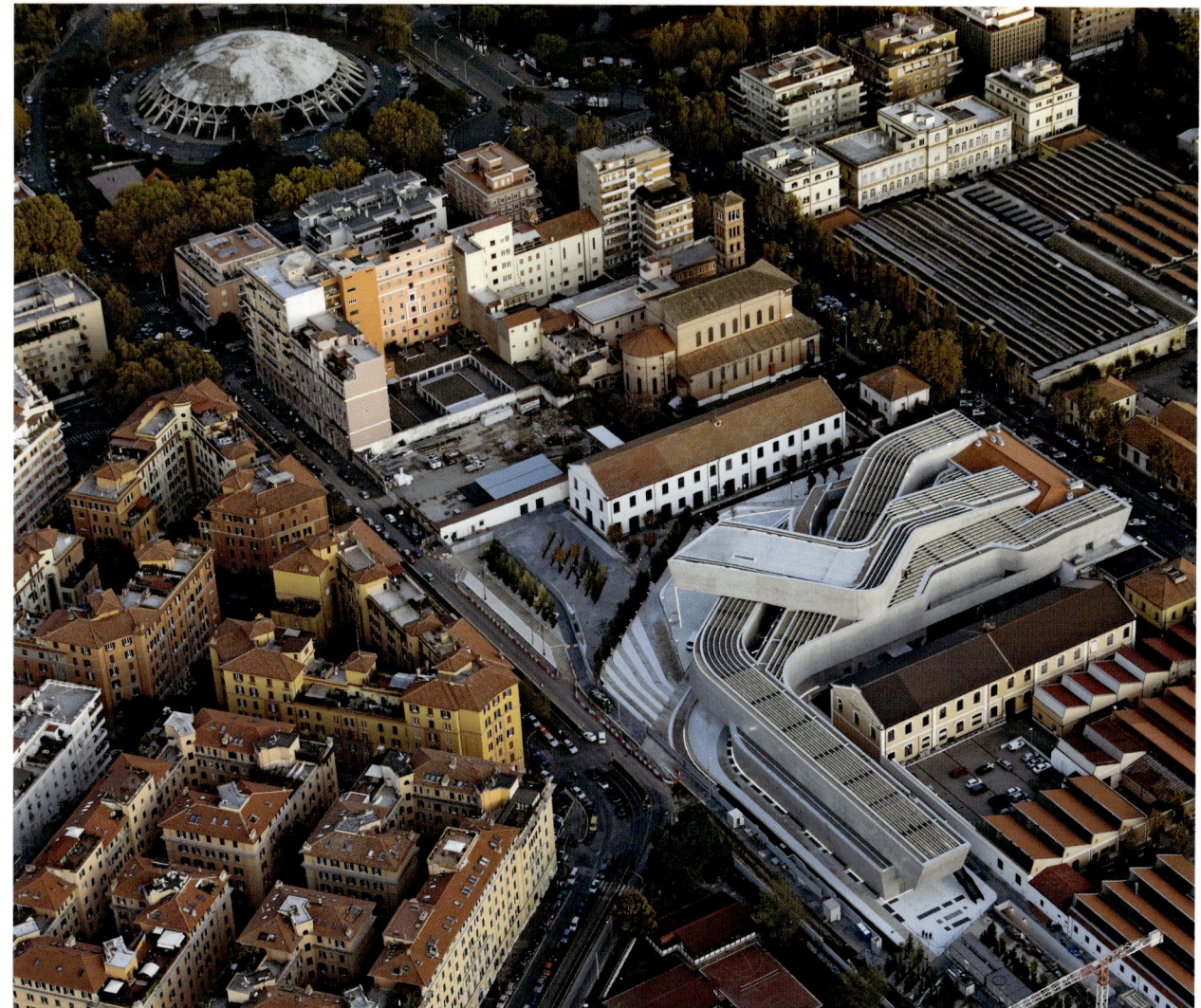

Aerial view 上空より見る
©Iwan Baan

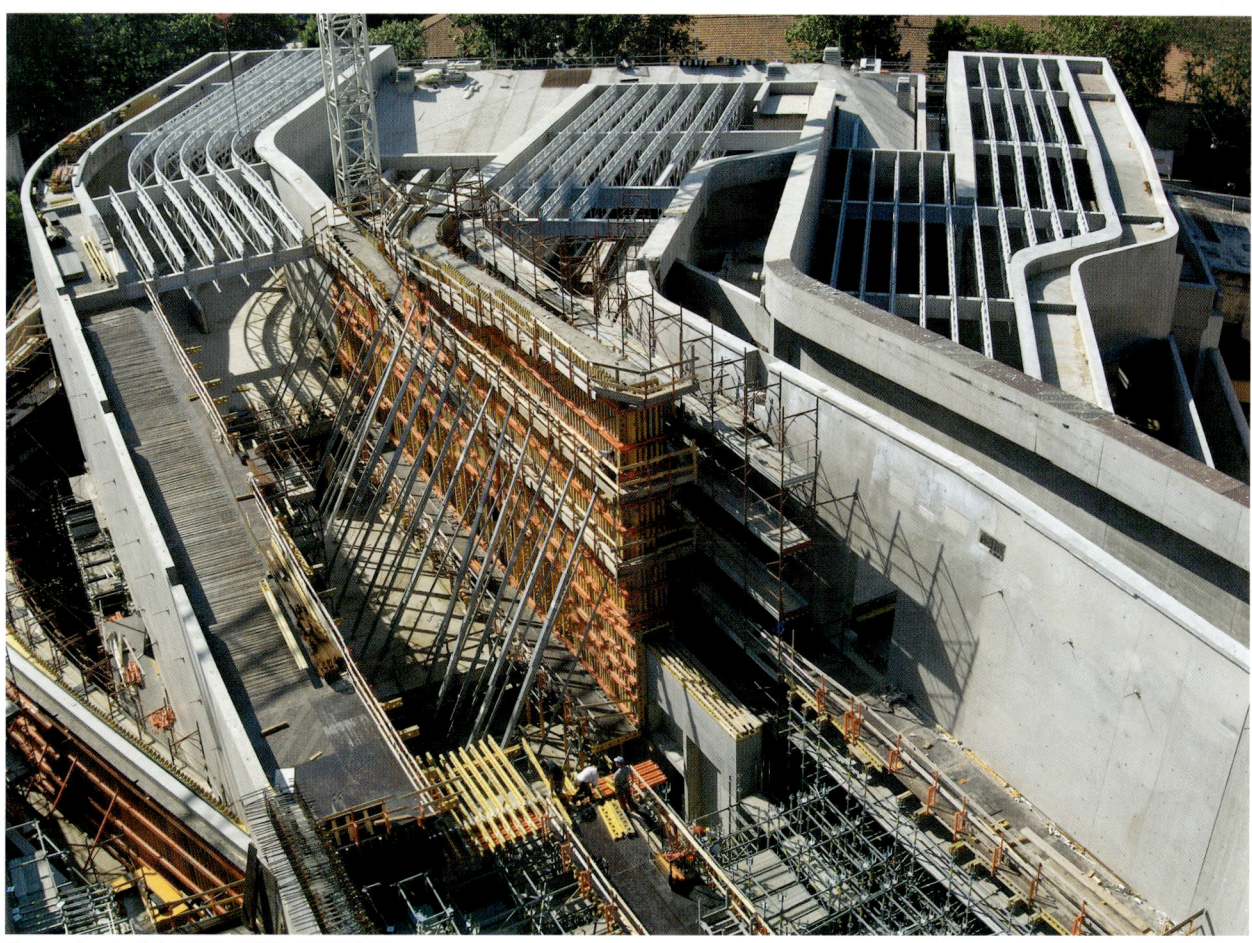

Construction site (July, 2005) 工事中（2005年7月）
©Hélène Binet

13

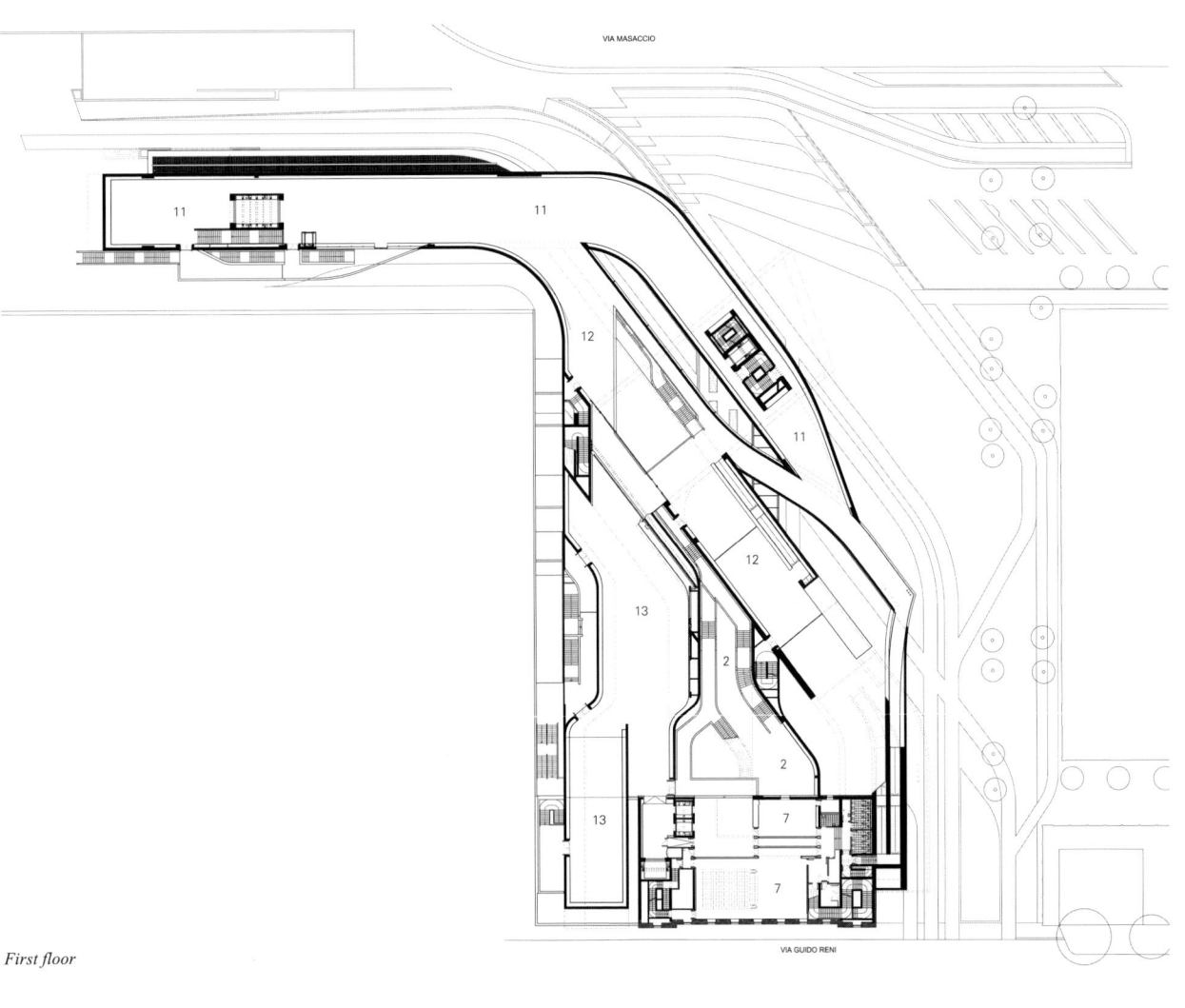

First floor

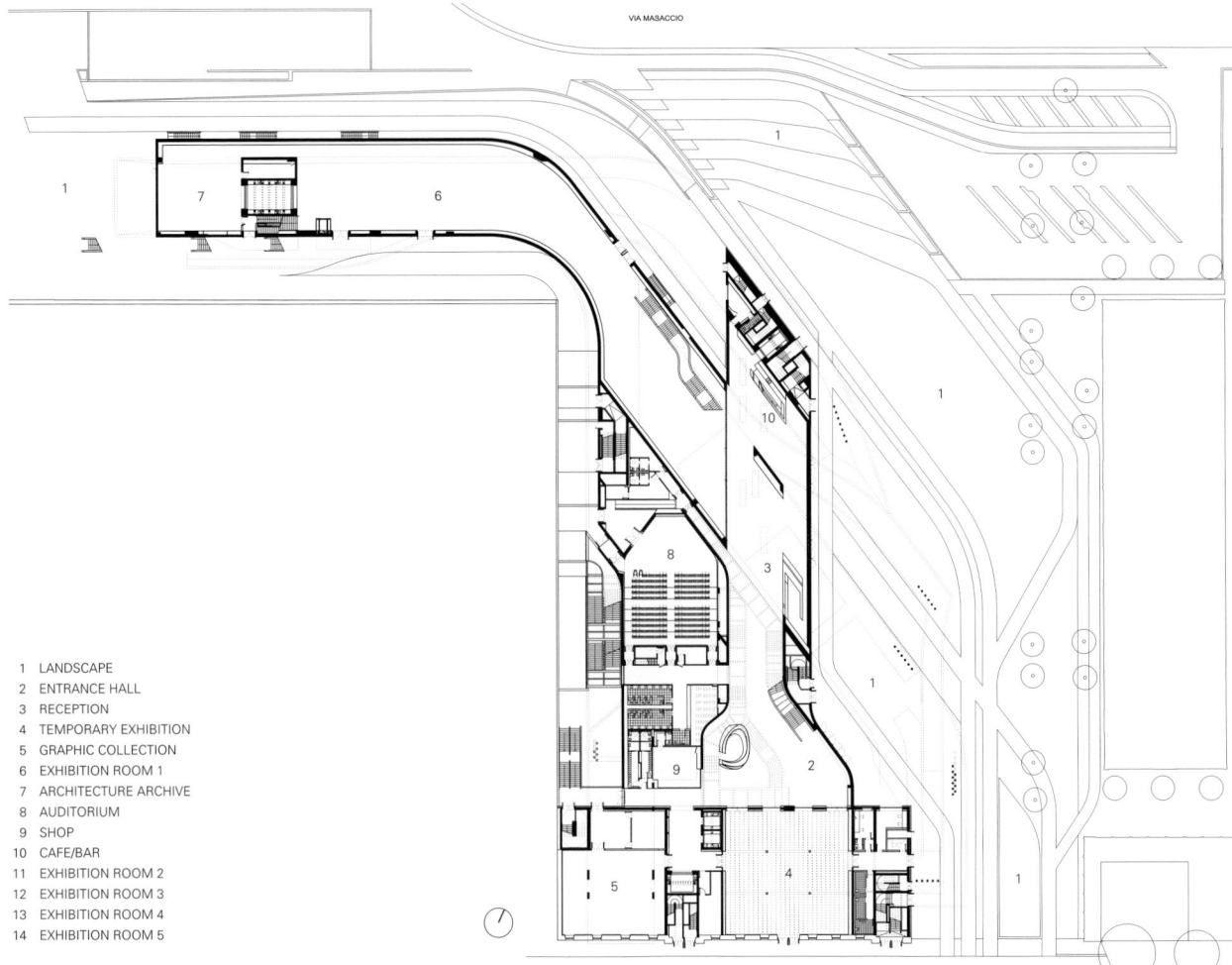

1 LANDSCAPE
2 ENTRANCE HALL
3 RECEPTION
4 TEMPORARY EXHIBITION
5 GRAPHIC COLLECTION
6 EXHIBITION ROOM 1
7 ARCHITECTURE ARCHIVE
8 AUDITORIUM
9 SHOP
10 CAFE/BAR
11 EXHIBITION ROOM 2
12 EXHIBITION ROOM 3
13 EXHIBITION ROOM 4
14 EXHIBITION ROOM 5

Ground floor

は，芸術作品ではよく理解されているが，建築世界の中では，依然として異質な主張である。この機会をとらえて，こうした先進的な建物をデザインするという大胆な試みのなかに，1960年代後半以来，芸術活動によって喚起されてきたマテリアルとコンセプトの不一致という問題に向き合うことにしたのである。通路は"オブジェクト"とその相互依存関係にある神聖化から離れ，変化の必要が予測される多様な関連フィールドへと導く。

〈インスティテューショナルな触媒〉

こうして，この新たに設立されるインスティテューション（芸術と建築を共に収める）に可能な独自性を設計することが重要であると考えた。21世紀の多様な複雑さに対する願望と共に，空間構想とテンポラリティそのものが再生される。モダニストの夢想的な空間は20世紀の美術館の大半を白い"ニュートラリティ"で覆い尽くした。今，これは異議を申し立てられるに違いない。単に意志的な否定からではなく，建築はコンテンポラリーな社会とその美的規範との関係を持ち続ける必要が重要であるゆえにである。芸術作品の展示法に対する絶対主義的な考え方は，現在，不確定的な留保状態にあるので，われわれが強く惹かれている"展示を最大限に活用する"アイディアへ向かうことができる。このシナリオのなかで，美術館はまず第一に，未来を見据えた論考のための触媒となると同時に，芸術を見せることと建築との分岐に対する多様な可能性をつくりだす。さらにまた，この重要なインスティテューションの"署名的"側面は，独自性を備えたいくつもの形態を同時に進展させる，よりしなやかで多孔性の有機体へと昇華される。

〈壁／非壁：今日的な空間性へ向けて〉

建築的な点からは，これは"壁"という表象によって，最も悪意的につくられている。絵画の展示のための，"秩序"や線形の"物語"を構築するための，分離した空間の輪郭を描

くための，特権的で，不変の垂直な骨格としての，美術館内の伝統的な符号である"壁"に対抗して，壁を束縛から解放することで，その批評を提起する。"壁"は展示効果の演出のための万能のエンジンとなる。多彩な外貌を持つ展示壁は——ソリッドな壁，映写スクリーン，キャンバス，都市を望む窓——主要な空間構成の装置である。敷地を横断し，隅々まで巡らされ，流れるように，身振りをつけながら，壁を構成する線は内部と外部を進んでいく。都市空間は，同じ操作のもとで，絶え間なく振幅しながらパヴィリオンとコートを取り替えつつ，展示室と同時に存在する。そして壁の古典的構成からのさらなる逸脱が偶発的に現れる。そこでは，壁が床になり，あるいはねじれて天井になり，あるいは取り除かれて外を見る大きな窓になる。寸法と幾何学を絶え間なく変えることで，壁はどのようなキュレーター的役割が必要となろうと自身を適応させる。展示室内に，天井のリブから吊り下げられた一連の間仕切りを設置することで，多様な展示空間がつくられる。こうして，構成的，空間的な工夫は，同時に，天井のリブへ壁が共鳴するリズムそのものと関わることになる。天井はまた様々な明るさの光を濾過する。

〈ドラマとしての思考／芸術のための舞台〉
ドラマを変えることのできる可動要素，建築が芸術の"演出"を行うのはこの方法によってである。"舞台装置"は展示室の概念的な要素から構築できるだろう。これらは物質化するか非物質化するかに応じて，その時々の展示の独自性に適合される。

美術館全体の緩やかな流動性は，多様な環境，フィルターをかけられた光景や様々な光の中を貫く軌道である。キュレーターの手に新たな自由を付与する一方で，逆に，これは芸術品と，それが置かれる環境の解放された対話として，芸術鑑賞者の経験を要約し再構成する。

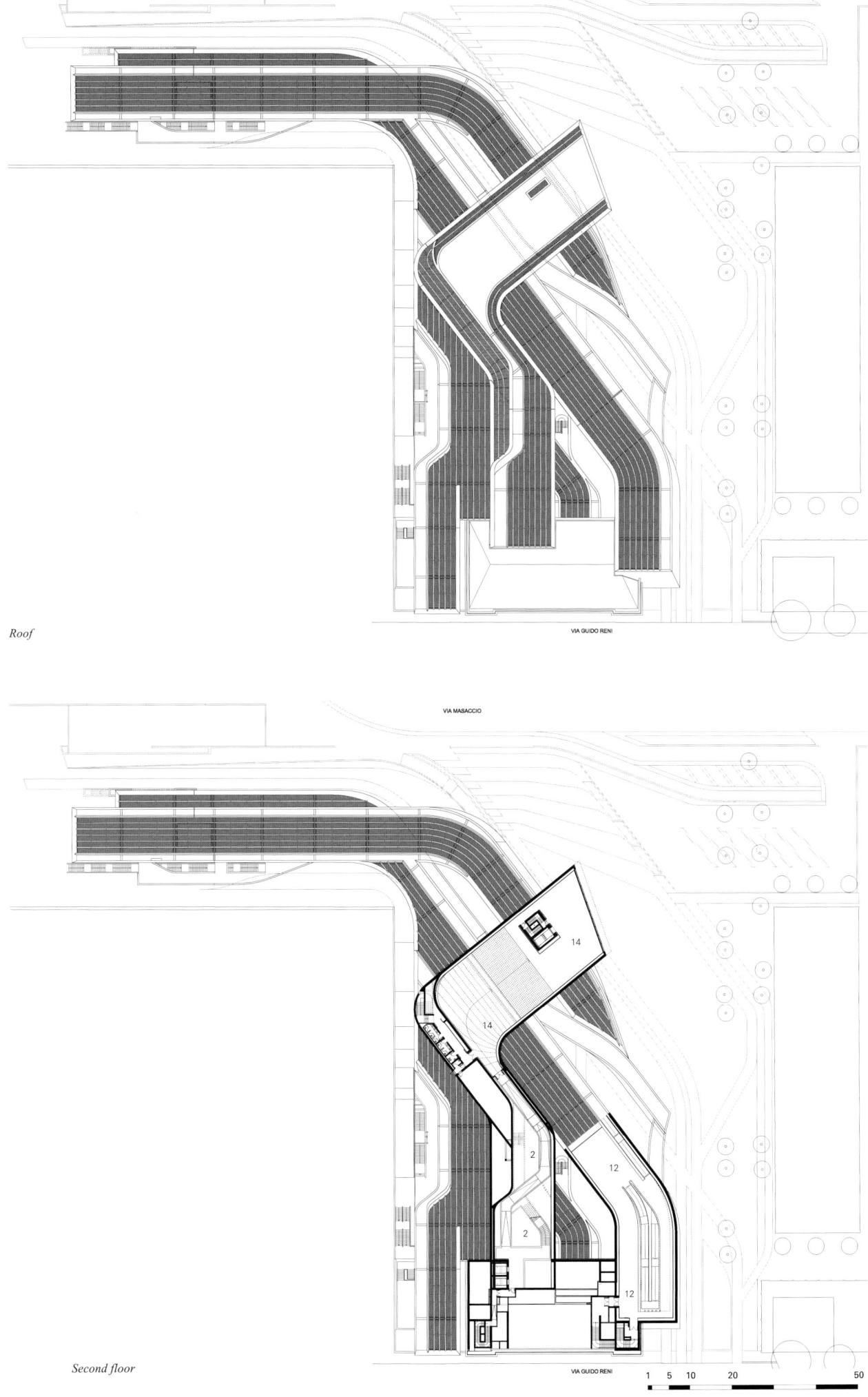

Roof

Second floor

View from plaza on east　東側広場より見る

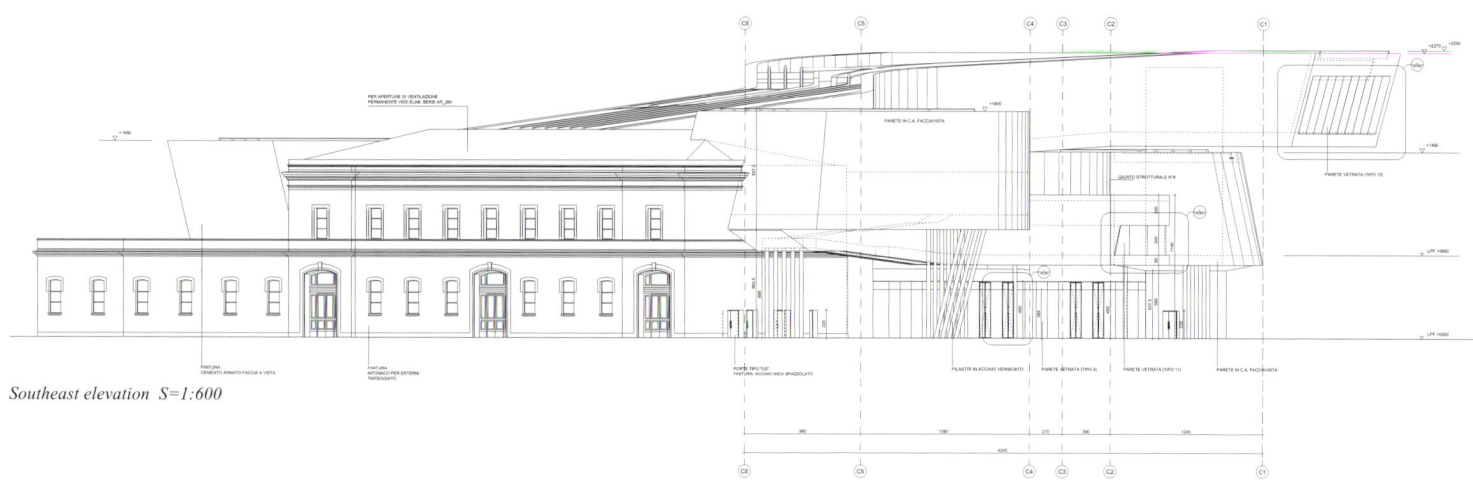

Southeast elevation S=1:600

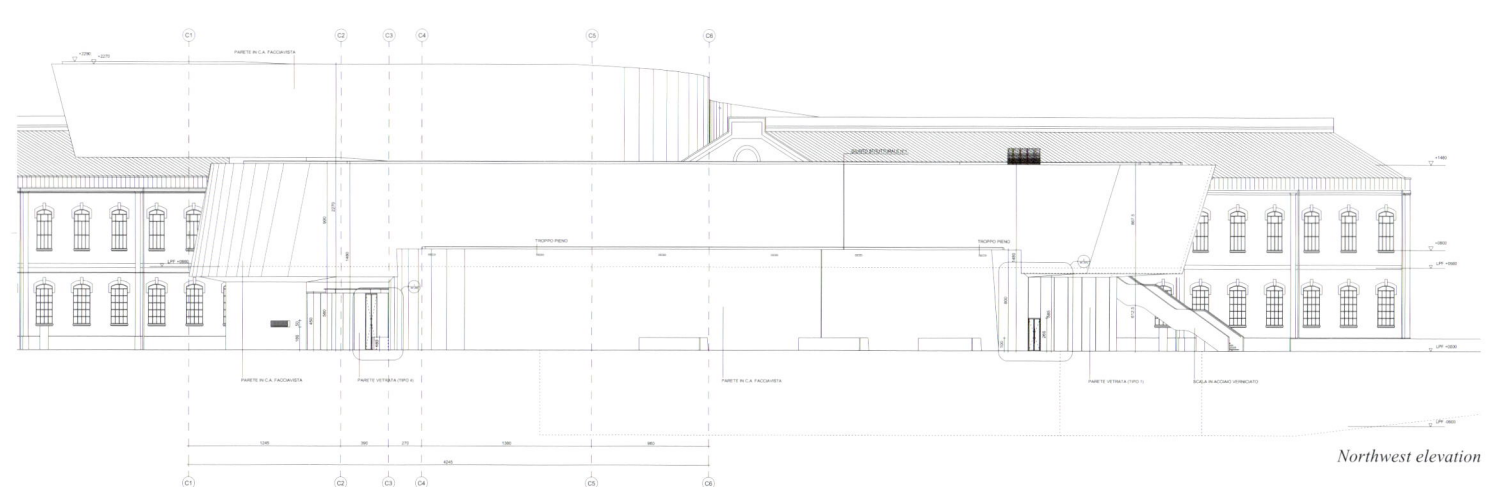

Northwest elevation

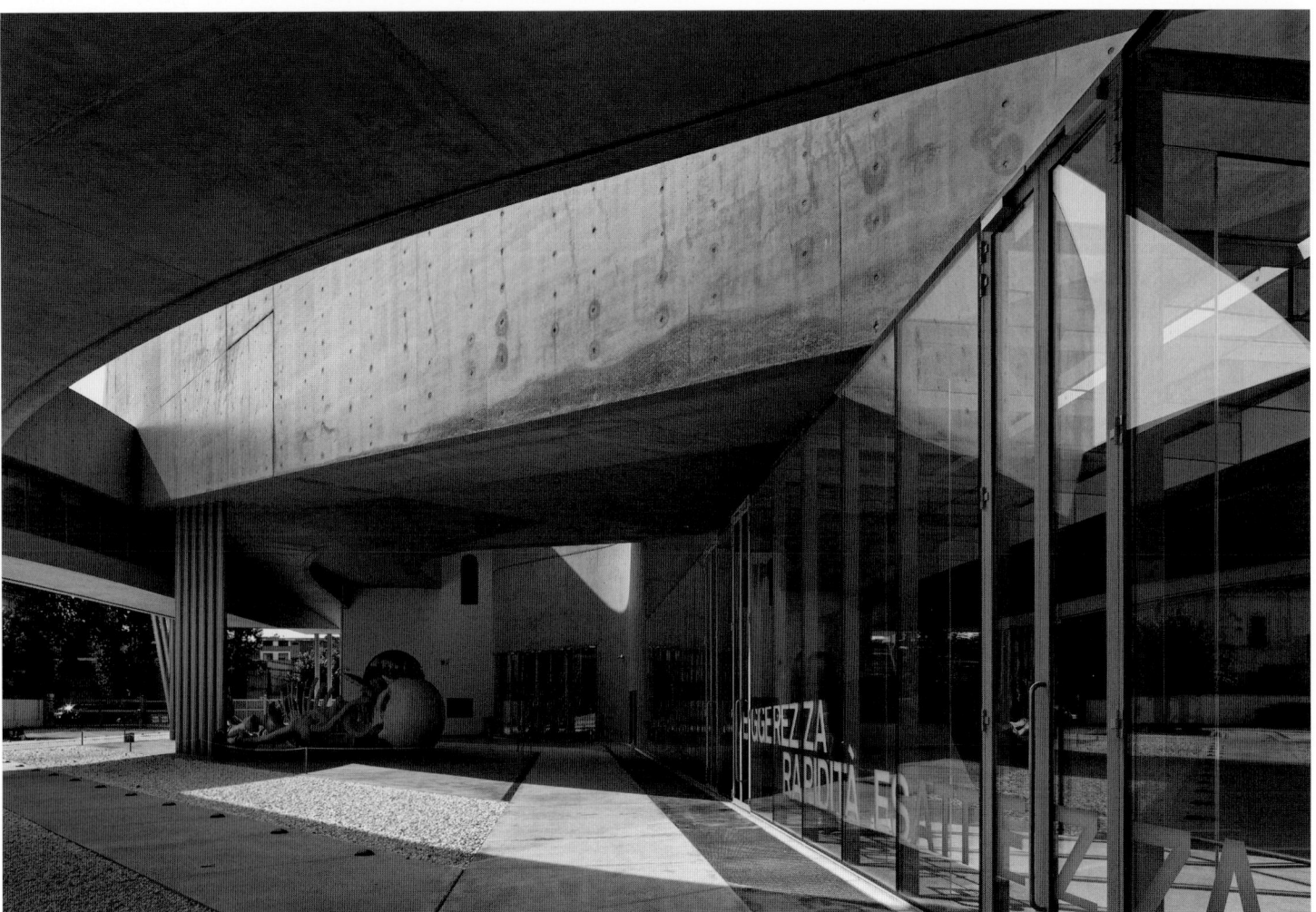

Plaza and pilotis: view toward main entrance　広場とピロティ：メイン・エントランスを見る

Pilotis on main entrance　メイン・エントランス前のピロティ

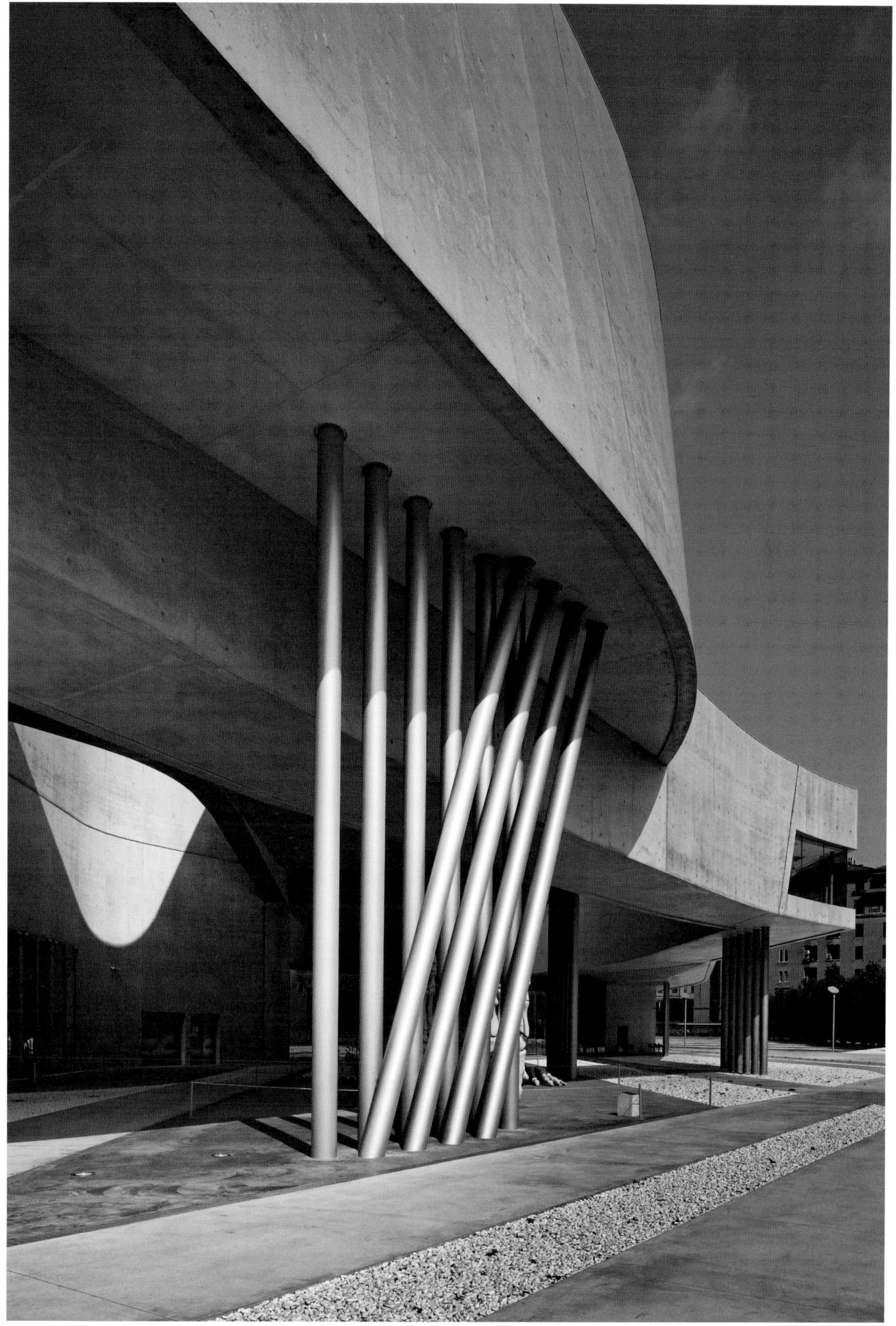

Pilotis ピロティ

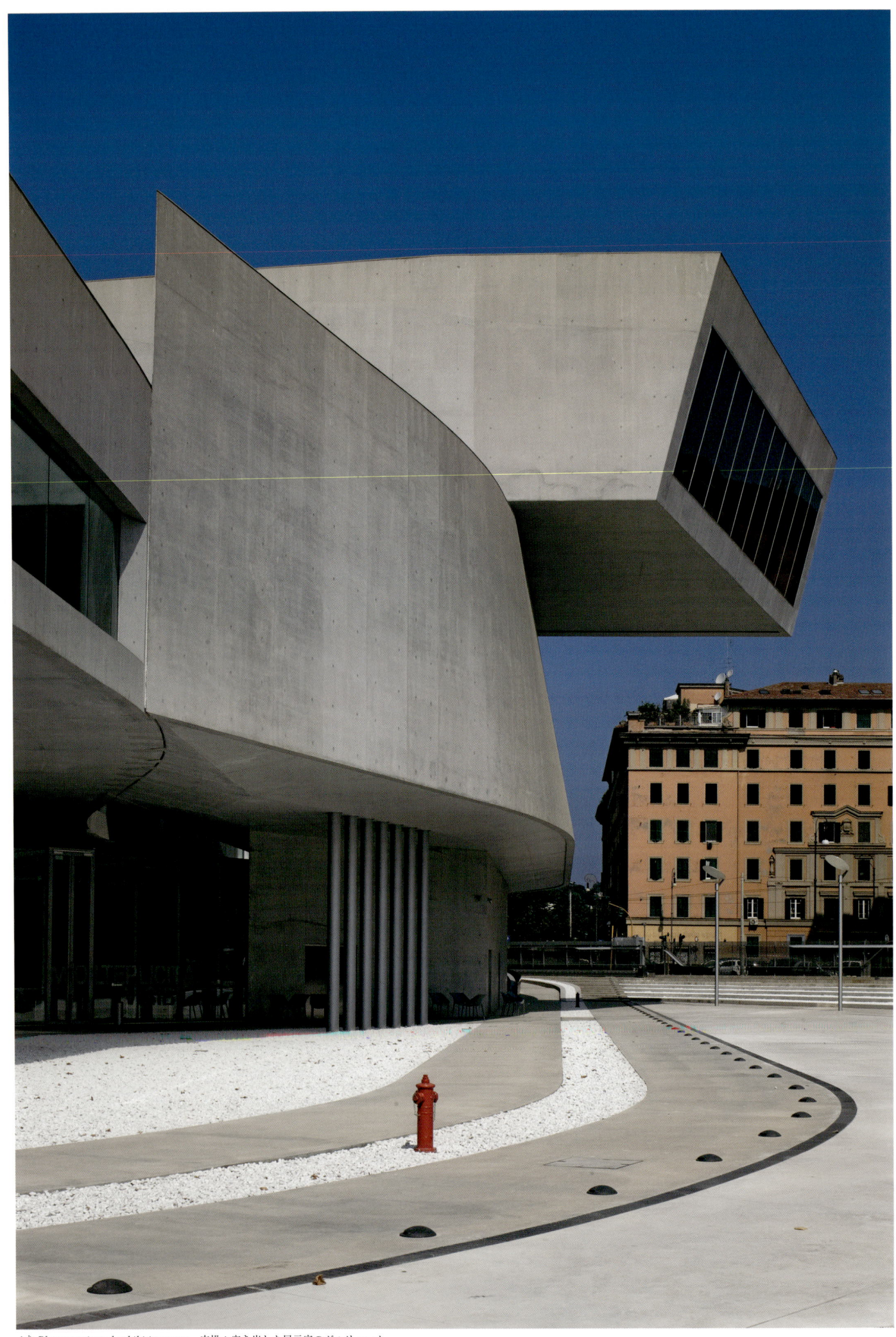

△▷ *Plaza: projected exhibition room*　広場：突き出した展示室のヴォリューム

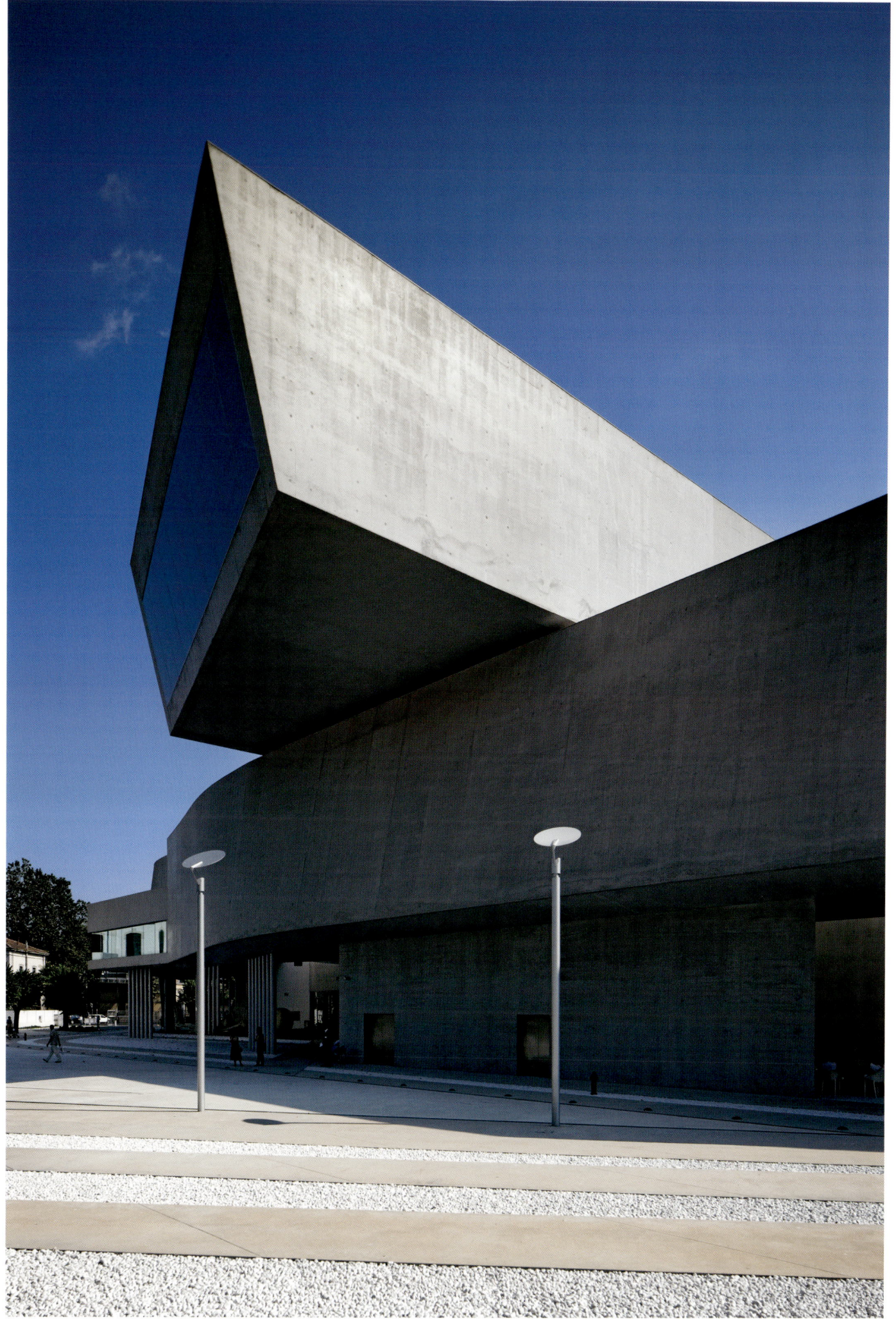

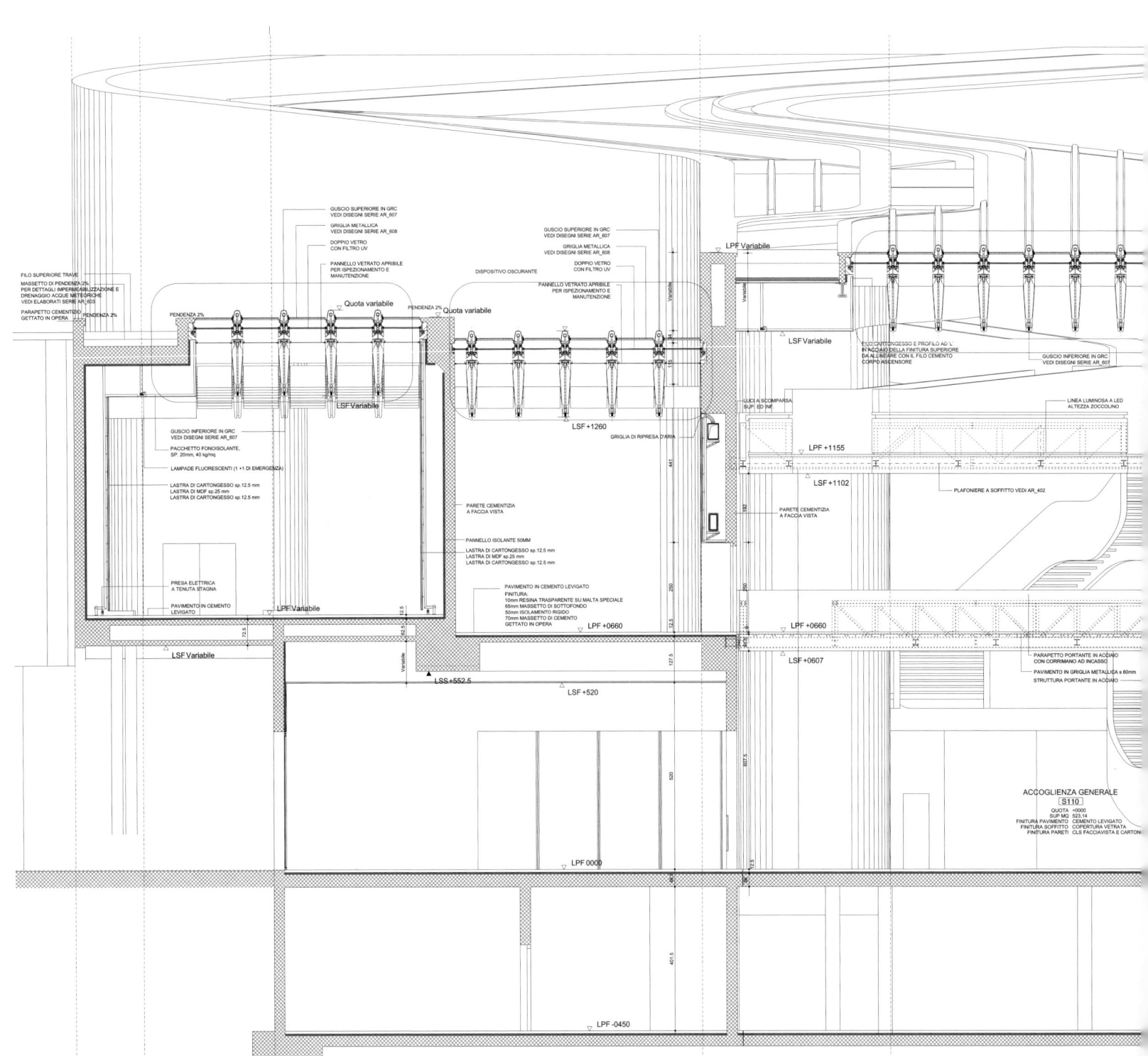

Cross section (entrance hall and exhibition room) S=1:140

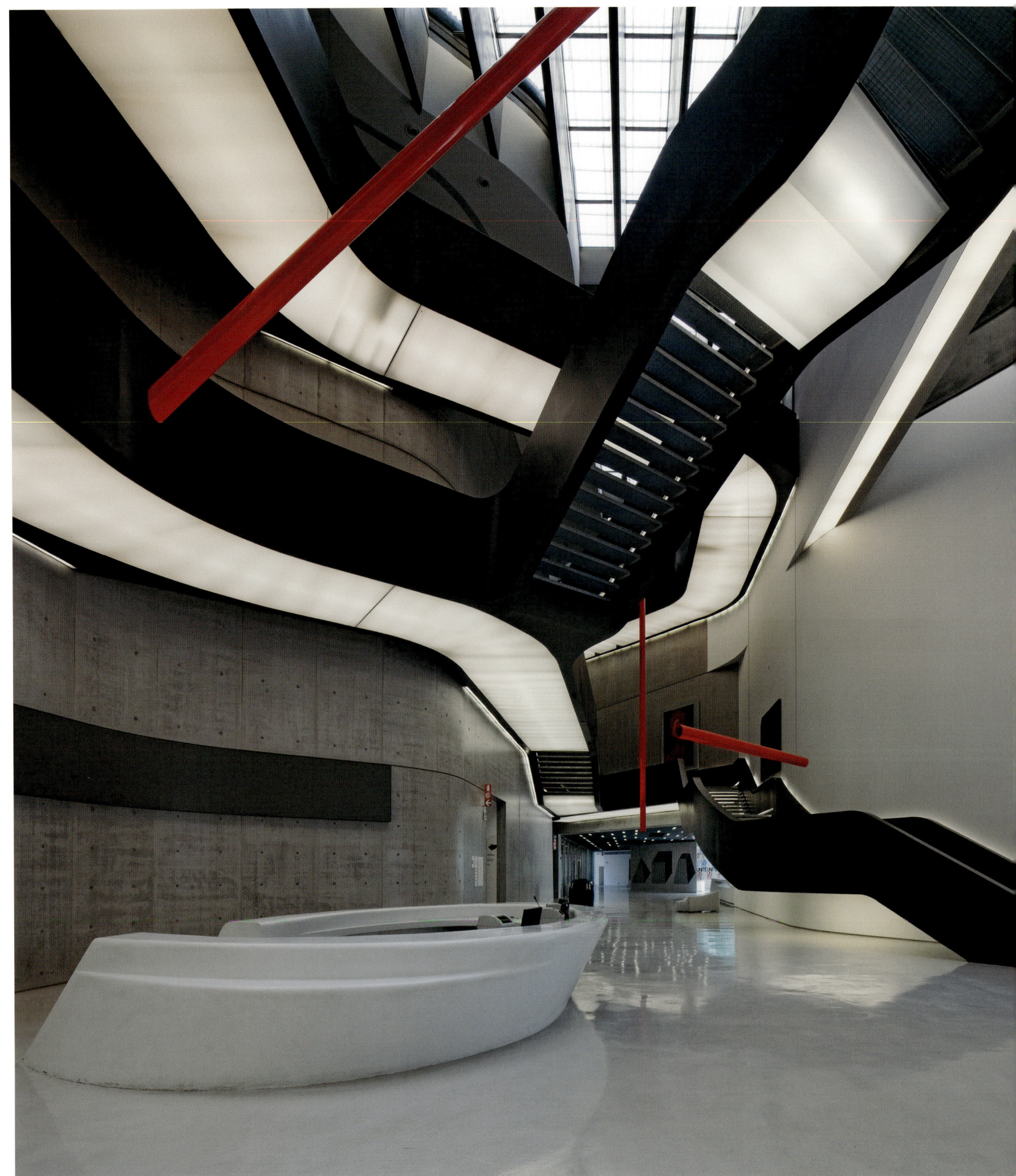

Entrance hall エントランス・ホール

View toward entrance hall エントランス・ホールを見る

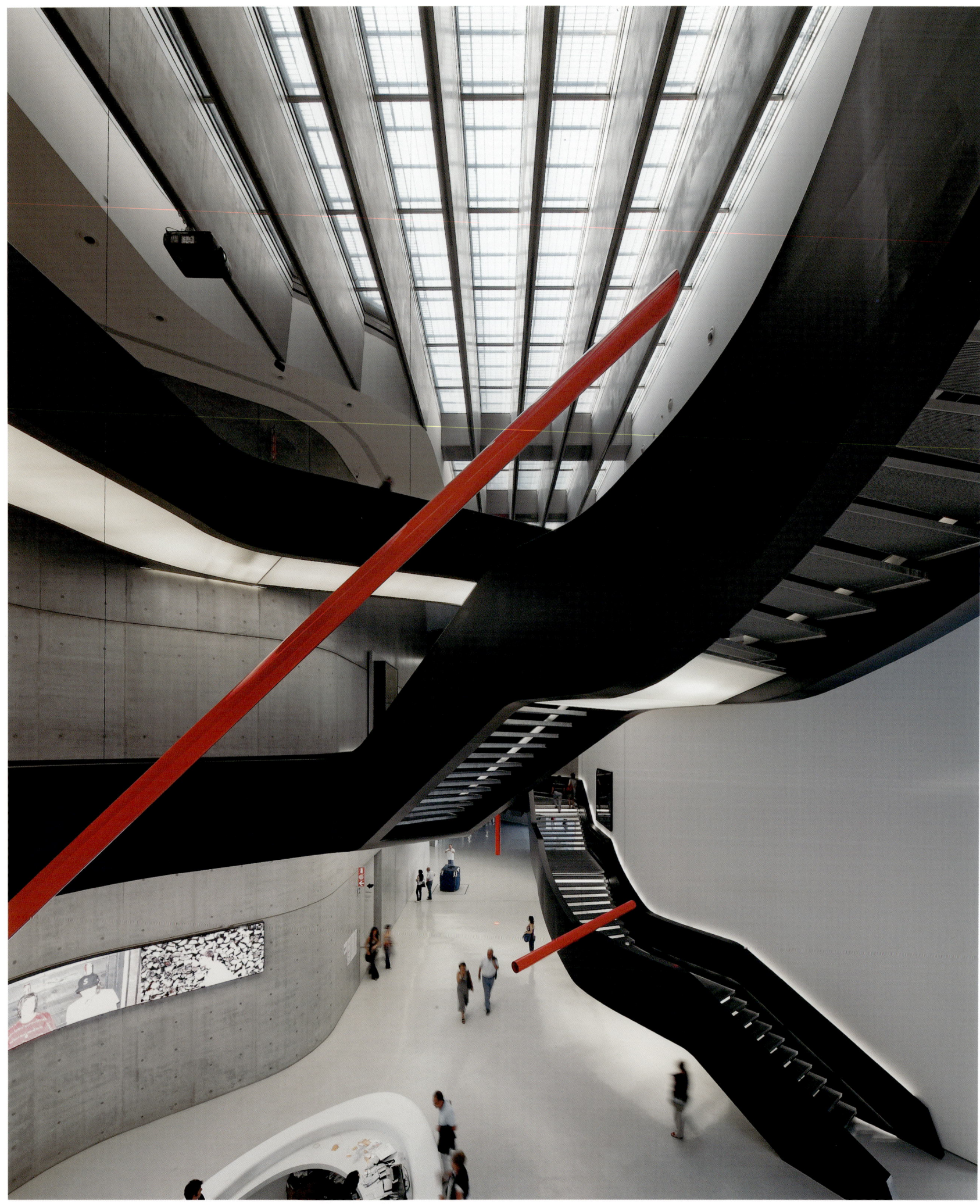

Upper part of entrance hall: view from first floor エントランス・ホール上部：2階より見る

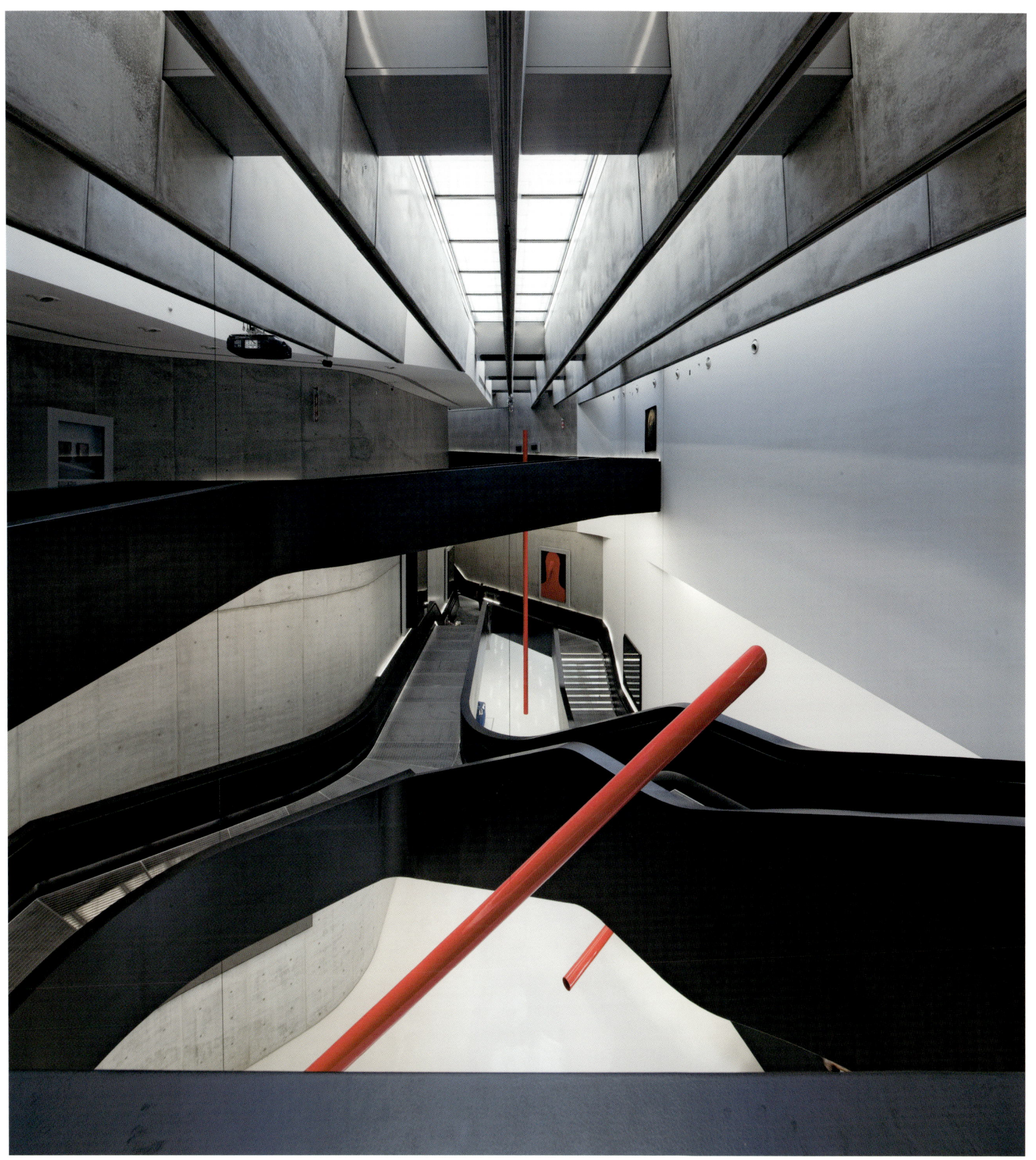

Upper part of entrance hall: view from second floor　エントランス・ホール上部：3階より見る

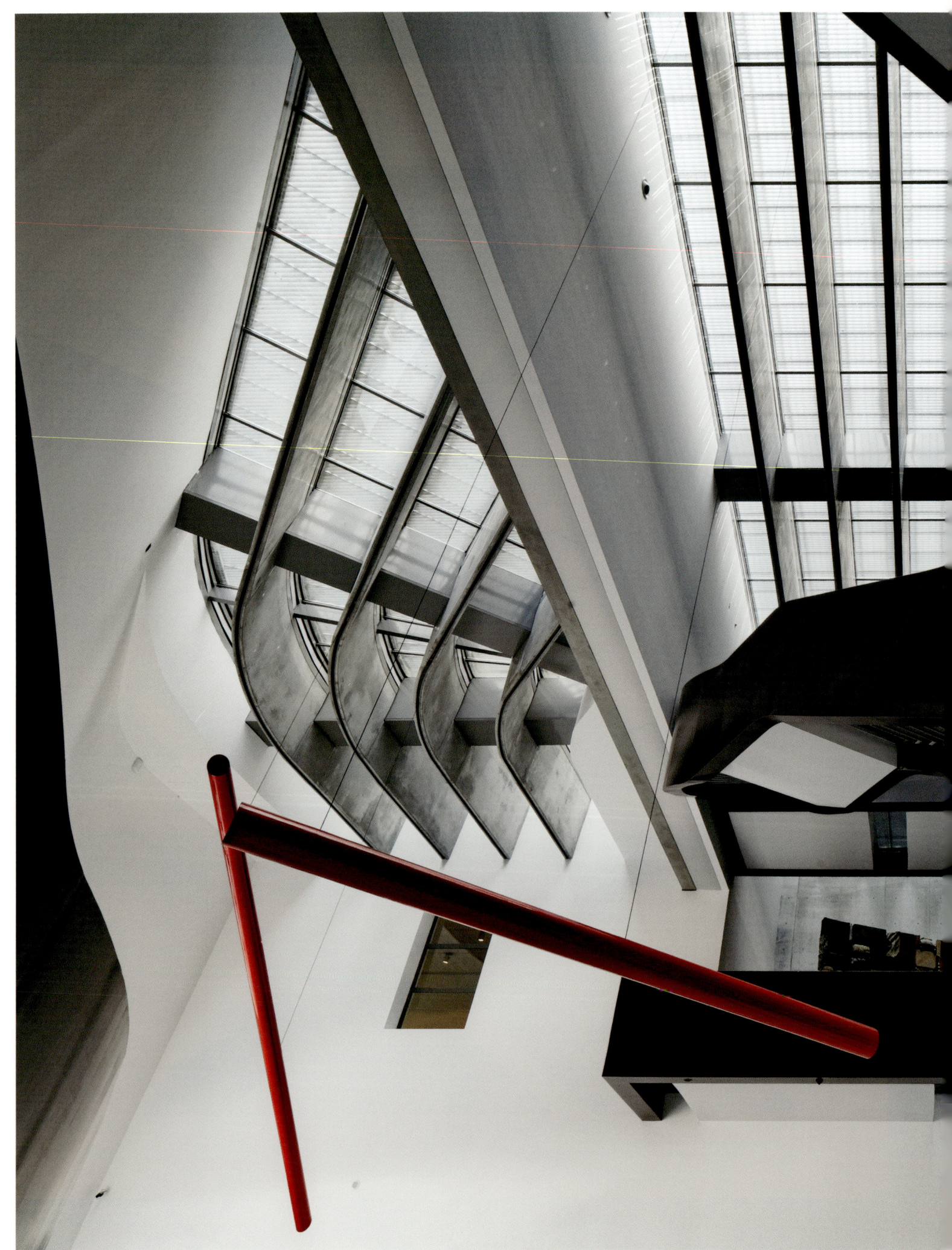

Upward view from entrance hall　エントランス・ホールより見上げる

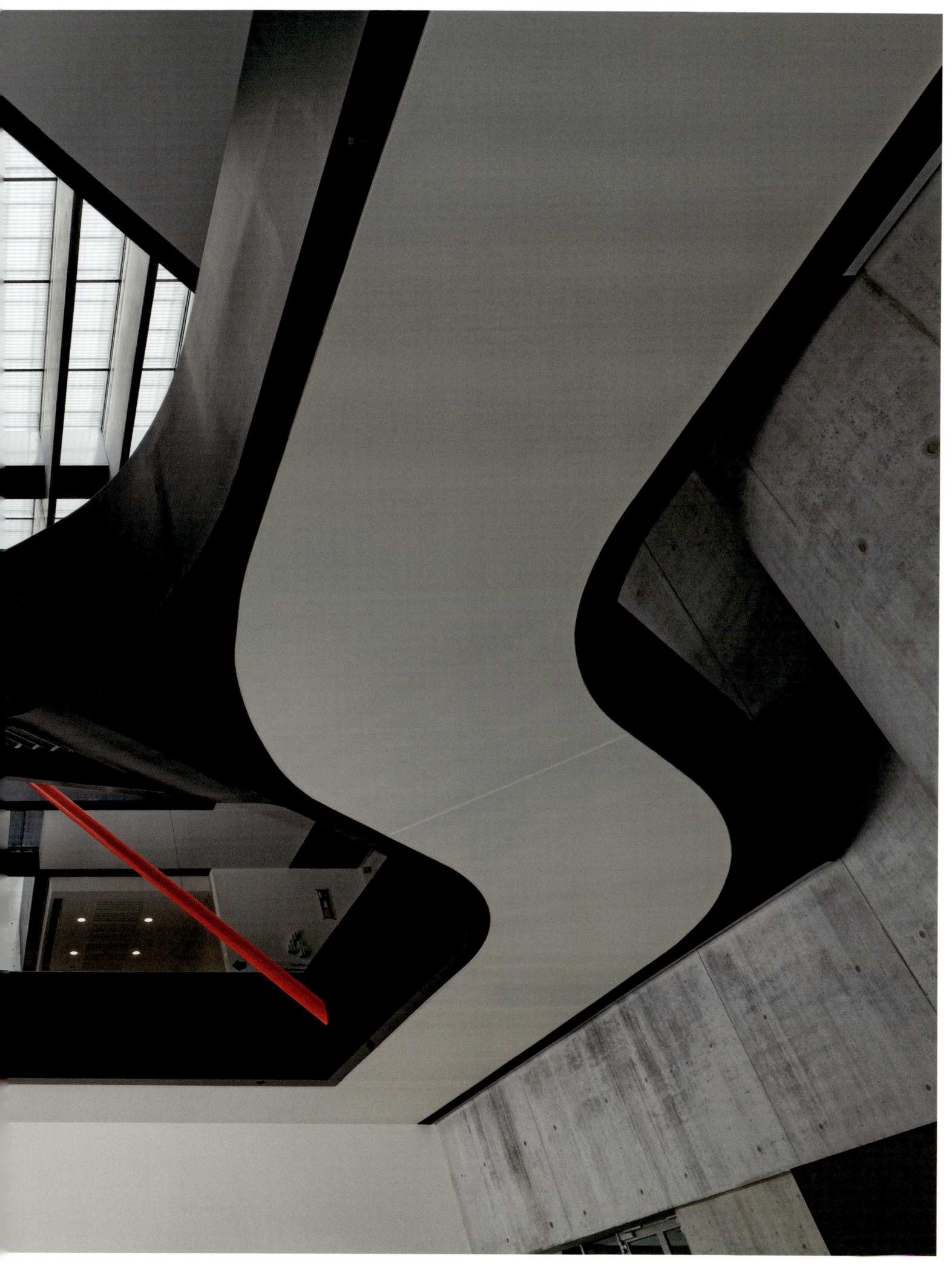

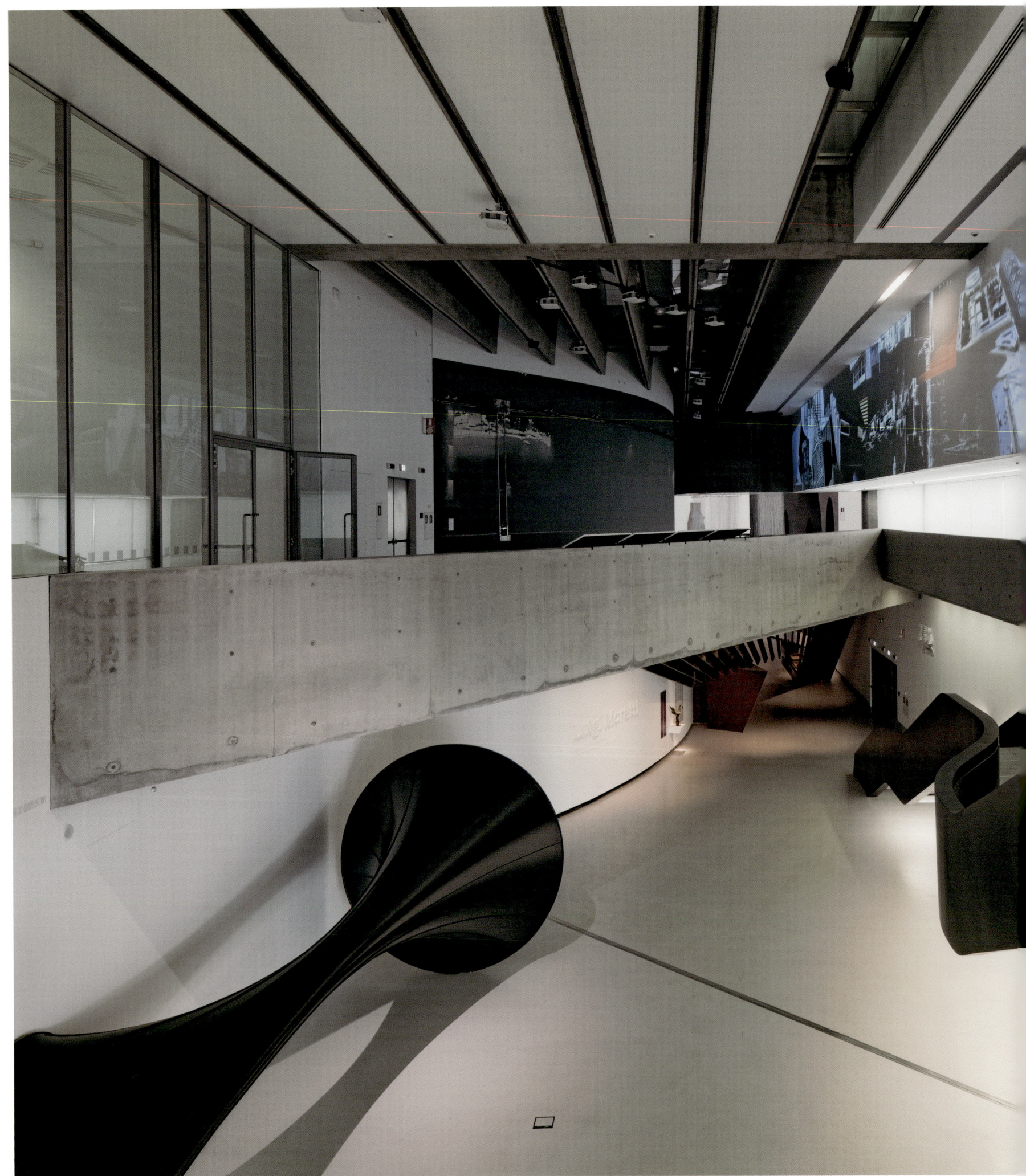

Void: exhibition room 1 (below), exhibition room 3 (above) 吹抜け：下は展示室1，上は展示室3

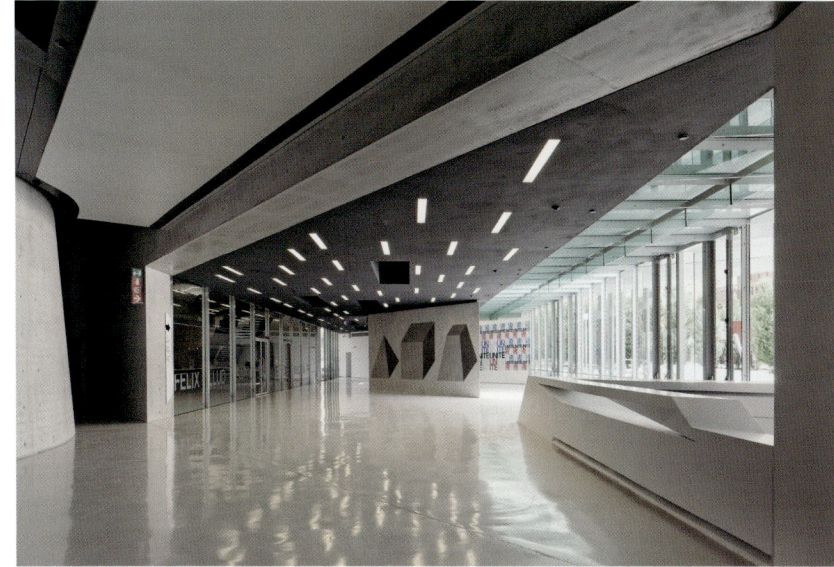

Reception: exhibition room 1 on left　レセプション：左は展示室1

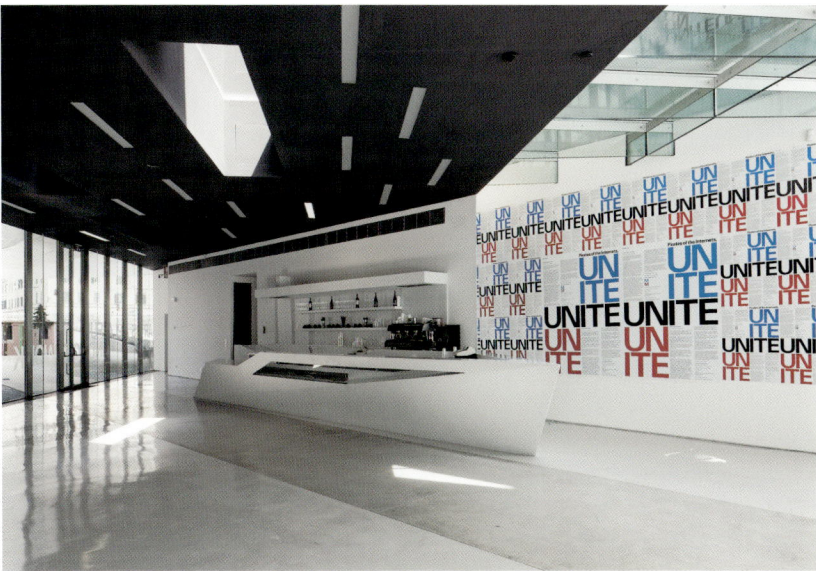

Cafe/bar　カフェ／バー

First floor: exhibition room 3 on right. Passageway to east end on left and connected to ramp on center　2階：右は展示室3。左は東端へ続く通路，正面のランプに通じる

First floor: exhibition room 3　2階：展示室3

First floor: exhibition room 4 2階：展示室 4

First floor: exhibition room 2 2階：展示室 2

33

Circulation route: view toward entrance hall　交差する階段と通路：エントランス・ホールを見る

Circulation route above entrance hall　エントランス・ホール上部，動線となる階段と通路

Circulation route on second floor　3階，階段と通路

Exhibition room 5 projected toward north　北側に突き出した展示室5端部

Exhibition room 5 on second floor　3階展示室5

37

Ramp at east end: connects to exhibition room 3　東端のランプ：展示室3に続く

Detail of ceiling (exhibition room 3)

First floor: ceiling plan (east end)

△▽▷ *Architecture Archive on ground floor*　1階，建築アーカイブ

Cross section: exhibition rooms

41

The Parametric City
Patrik Schumacher

The cities of the future can only be sustainable if they become truly parametric.

Our technologically based world civilization has expanded its power of wealth creation to the point where it becomes its own barrier. We are finally compelled to recognize the finitude of our planet. Our world has shrunk to this single, fragile, shared "spaceship planet earth". Every new enterprise must now involve an additional reflective loop about its potential ecological consequences.

Cities are a crucial conduit of our global consumption of energy, air and water. Buildings consume energy and pollute during their life cycle as well as during their fabrication and construction. The ecological sustainability of our civilization depends upon our ability to find more intelligent and light-footed ways to harness and utilize the finite resources of our natural environment. This necessity imposes a new constraint upon the design of our built environment, not only in terms of new technology and innovative engineering solutions, but also in terms of the architectural order and stylistic expression of the built environment. However, the imperative of energy saving must not imply that the shutters are coming down. The task is to create cities that sustainably adapt to the natural environment without arresting the progressive, developmental thrust of our civilization.

Cultural advancement has to continue. This is not only an end in itself but the sine qua non of our continued survival on spaceship earth. Continuous technological innovation is a necessary precondition for our ability to ascertain our ongoing ecological sustainability. Therefore the tightening of ecological constraints that impose themselves upon the design of cities must not constrain the vitality and productivity of the life processes they accommodate. Cities must continue to provide the living conditions that are favourable to innovative work. Thus before we can fully address the question of how to optimize our cities in terms of environmental engineering we must answer the question which urban patterns and architectural morphologies are most likely to vitalize and advance the productive life and communication processes everything else depends upon.

This latter question involves architecture's enduring core competency and societal function, namely to order and frame societal communication via the innovative/adaptive design of the built environment. All social communication requires institutions. All institutions require architectural frames [1].

The prevalent institutions and communication patterns of society have undergone momentous changes during the last 30 years. Social communication has been dynamized, differentiated and intensified. The static organizing principles of Fordist Mass Society—separation, specialization, and mass repetition—have been replaced by the dynamic principles of self-organization of the emerging Postfordist Network Society: variation, flexible specialization, and networking. Accordingly Modernist urbanism (zoning) and Modernist architecture (serial monotony) experienced a fatal crisis.

The inherent limitations of the linear models of expansion that characterized Fordism had become apparent both in terms of the ecological, the socio-economic, as well as the urban crises of the 1970s. The pertinent theoretical answer developed in the form of complexity theory analyzing and simulating self-regulating systems ranging from simple, homeostatic feedback mechanisms via organisms to evolving eco-systems. The same theoretical resources and computational techniques that allow meteorologists to reconstruct and predict the global weather system and scientists to speculate about the earth's evolving climate are available to contemporary urbanists and architects in their effort to meet the challenges posed by the ongoing Postfordist socio-economic restructuring. The task is to project the growth and transformation of cities as a rule-based, largely self-regulating morphogenetic process. However, this emergent morphogenesis of the city is "designed" via computational processes (e.g. genetic algorithms) involving both generative processes as well as in-built selection criteria.

The emerging Network Society implies that the intensity of communication increases exponentially. Even while the use of the internet and mobile devices increases, the demand for face to face communication—mediated by architectural and urban spaces—increases too. That is why the solution cannot involve the shutting down of the urban porosity and urban flow. Postfordism requires new, more variegated, complex, and densely integrated patterns of spatial ordering that are inherently multivalent and adaptive. In retrospect Postmodernism (1980s) and Deconstructivism (1990s) might be understood as first groping steps in this direction. They have since been superseded—their partial insights and discoveries being preserved and elaborated—by a new powerful paradigm and style that promises to guide a new long wave of design research and innovation: Parametricism [2].

Parametricism is gathering momentum to become the first new global, unified style that can and must replace Modernism as credible epochal style. Parametricism confronts both, the remaining vestiges of Modernist's monotony, and the cacophony of the urban chaos that has sprung up in the wake of Modernism's demise, with a complex, variegated order inspired by the self-organising processes of nature. The premise of Parametricism is that all urban and architectural elements must be parametrically malleable. Instead of assembling rigid and hermetic geometric figures—like all previous architectural styles—Parametricism brings malleable components into a dynamical play of mutual responsiveness as well as contextual adaptation. Key design processes are variation and correlation. Computationally, any property—positional, geometric, material—of any architectural element can be associated with—made the "cause" or "effect" of—any other property of any other element of the design. The designer invents and formulates correlations or rules akin to the laws of nature. Thus everything is potentially made to network and resonate with everything else. This should result in an overall intensification of relations that gives the urban field a performative density, informational richness, and cognitive coherence that makes for good legibility, easy navigation and thus quick, effective participation in a complex social arena where everybody's ability to scan an ever-increasing simultaneity of events and to move through a rapid successions of communicative encounters constitutes the essential, contemporary form of the cultural advancement.

The ecological challenge referred to above is among the defining moments of our epoch. Its impact on contemporary architecture and urbanism is second only to the challenge posed by the dynamic and complexity of Postfordist Network Society. Indeed, the general paradigm of "eco-systems" applies to both, and is embraced as founding paradigm of Parametricism. The same design concepts, techniques and tools of Parametricism that allow contemporary architects to ramp up the communicative complexity of the built environment are also congenial to the agenda of optimizing architectural forms with respect to ecological performance criteria. Morphological output variables can be programmed to respond to environmental input parameters. For instance, a data-set like a sun exposure map that maps the radiation-intensities a facade is exposed to during a given time period can become the data-input for the adaptive modulation of a sun-shading system. As the system of shading elements wraps around the façade the spacing, shape and orientation of the individual elements gradually transform and adapt to the specific exposure conditions of their respective location on the façade. The result is a gradient, continuously changing façade pattern that optimizes sun-protection relative to light intake for each point on the façade. At the same time, this adaptive modulation gives the building an organic aesthetic that also makes the orientation of the building in the environment legible and thus facilitates the comprehension and navigation of the urban environment. The differentiated articulation of the façade contains and transmits information about its position rather than remaining indifferent and blind. The same principle of conspicuous, adaptive variation and correlation is being applied to the activity and event parameters of the urban life process. The disorientating, generic neutrality and monotony of Modernism gives way to the ecologically adaptive eloquence of Parametricism.

[1] A theoretical elaboration of this definition of architecture's societal function can be found in Patrik Schumacher's forthcoming book *The Autopoiesis of Architecture*, to be published later this year (2010) by John Wiley & Sons Ltd.

[2] For a full statement of the meaning and merits of Parametricism see: Patrik Schumacher, *Parametricism: A new global style for architecture and urban design*, in Neil Leach (ed), *AD Digital Cities*, Architectural Design Vol 79, No 4, July/August 2009.

left: Galaxy Soho, Beijing China, 2009-
right: Stone Towers, Cairo, Egypt, 2008-

未来の都市は真にパラメトリックにならない限りサステイナブルとはなり得ない。

テクノロジーに基づいたこの世界文明は，それ自体が自らの障壁となるところまで力を拡大し富を創造した。我々はこの惑星の有限性を認識せざるを得なくなり，世界はたった一つしかなく壊れやすい，共用の「宇宙船地球号」へと縮小した。いま新たに企画される事業はすべて，そこに潜在するエコロジカルな影響について熟考する回路を伴わなければならなくなっている。

都市とは世界規模でのエネルギー・空気・水の消費に極めて重要なパイプ役を果たしている。建物は製造・建設過程のみならずそのライフサイクル全般においてエネルギーを消費し環境を汚染してゆく。文明のエコロジカルな持続可能性は，我々の自然環境において，限りある資源を有効利用するためのより知的，かつフットワークの軽いやり方を見いだす手腕にかかっている。それは新しいテクノロジーや革新的なエンジニアリングの解にとどまらず，建築環境の様式的表現や建築的秩序といった側面において，建築環境のデザインに新たな制約を課することになる。しかし，緊急を要するからといって，エネルギー節約が進化のシャッターを下ろすことにつながってはならない。やらなければならないのは文明発展の推進力の妨げにならないような，自然環境に順応したサステイナビリティを持つ都市の創造である。

文化は進歩し続けなければならない。それはそれ自体が最終目的であるだけでなく，宇宙船地球号での我々の生き残りをかけた必須条件である。絶え間ない技術革新は，進行形のエコロジカルな持続可能性を確認するために必要な前提である。よって，都市のデザインに課せられるエコロジカルな制約の強化が，そこで展開する生命過程の生産性や活力まで制約してしまってはならない。都市は，創造的活動がしやすい生活条件を提供し続けなければならない。つまり，いかに都市を環境工学の観点から最適化するかという課題にとりかかる前に，まずは生産活動やコミュニケーション過程といった基幹部分の発展や活性化に対して最も有効な都市パターンや建築形態は何かという問題にきちんと取り組むべきである。

この後者の課題は建築の永続的な能力特性と社会的機能に関わる，つまり建築環境の革新的な適応的デザインを通じて社会的コミュニケーションの秩序と枠組みを形成するものである。すべての社会的コミュニケーションには機構が必要であり，すべての機構には建築的枠組みが必要である。[1]

従来の社会におけるコミュニケーション・パターンや機構はこの30年間で大きく変化した。社会的コミュニケーションは活発になり，分化し，増強された。フォード式大量生産社会の静的構成原理（分離，専門化，大量反復）は，ポスト＝フォード式ネットワーク社会の自己組織性の動的原理（バリエーション，柔軟的専門化，ネットワーキング）に取って代わられた。それに伴い，近代的アーバニズム（ゾーニング）ならびに建築（連続的な単調感）は致命的な打撃を受けた。

1970年代のエコロジカル・社会経済的・都市的危機に際し，フォーディズムの特徴である拡張の線形モデルに内在する限界は，白日の下にさらされた。そこで得られた理論的解答は，複雑性理論分析と単純で恒常的なフィードバック・メカニズムから有機体を経て，発展的エコ・システムまでに至る自己制御システムのシミュレーションという形をとった。気象学者が地球規模の気象系を再現し予測する，あるいは科学者が地球上に発生する気候について推測を行う際に使用するのと同じ理論的リソースや計算技術が現代の都市計画専門家たちに供せられており，進行中のポスト＝フォーディズム社会経済の再編成への挑戦に役立っている。目指すは規則に基づく，概して自己調整型の形態形成プロセスとしての都市の成長と転換の計画である。しかし，ここで出現する都市の形態形成は，計算プロセスによって「デザインされ」（例：遺伝的アルゴリズム）ており，これは生成プロセスならびに予め組み込まれた選択基準にも関連している。

新しいネットワーク社会が暗示するのは，コミュニケーションの度合いが指数関数的に上がるという点である。インターネット利用やモバイル機器の使用率が増加しても，対面コミュニケーション（建築・都市空間を通じた）の需要も同様に増えてゆく。

それが，都市の多孔性や流動性を停止してしまうような解が許されない理由である。ポスト＝フォーディズムは本質的に多価で適応的な空間秩序の，変化に富んで複雑で密に統合された新しいパターンを必要としている。振り返ってみると，ポストモダニズム（1980年代）や脱構築主義（1990年代）は，こういった方向への手探りの中での最初の一歩であったのだと解釈することもできよう。どちらもその後，それぞれの部分的な見識や発見が保護・推敲されたのち，デザイン研究と進化の新しく大きな波を導こうとする新たな力強いパラダイムならびに様式に取って代わられた。それがパラメトリシズムである。[2]

パラメトリシズムは，確かな画期的スタイルとしてのモダニズムに取って代わり得る，そして取って代わるべき，初めてのグローバルで統合的なスタイルとしての機運が高まっている。パラメトリシズムが立ち向かうのは，モダニズムの単調感の痕跡およびモダニズムの終焉前夜に誕生した都市のカオスの不協音であり，自然界の自己組織プロセスに発想を得た，複雑で変化に富んだ秩序を伴う。パラメトリシズムには，すべての都市そして建築要素はパラメトリックな順応性を有していなければならないという前提がある。これまでのすべての建築様式がそうであったように，柔軟性がなく閉ざされた幾何学的図形を寄せ集めるかわりに，パラメトリシズムは順応性のある構成要素を相互反応性や状況適合のダイナミックな動きへと導く。デザインプロセスにおいて重要なのはバリエーションと相関関係である。計算上は，いかなる建築要素のいかなる特質（位置，幾何学，素材）も別のデザイン要素の別の特性と結びつける（理由付けや影響として）ことが出来る。デザイナーは自然の法則と類似的な規則や相関関係を創成し組み立てる。従って，すべては互いに共鳴しネットワーク化する可能性を有している。結果，全体的な関係の強化は，密度のあるパフォーマンスと豊かなインフォメーションと認識の一貫性を都市圏に与え，良好な視認性，容易なナビゲーション，そして人々の同時多発性が高まり続ける数多のイベントを走査する能力と，コミュニケーション上でのめまぐるしい数々の出会いを駆け抜ける能力が，文化発展の本質的な現代的形態を構成するような，複雑な社会活動の領域への機敏かつ効果的な参加を可能にしている。

先述のエコロジカルな挑戦は，我々の時代における決定的な出来事の一つと言える。それが現代の建築ならびに都市様式に及ぼすインパクトは，ポスト＝フォード式ネットワーク社会の動的な複雑性が投げかけた挑戦の次に大きなものである。実際，「エコシステム」の一般的なパラダイムはその両方に適用され，また，パラメトリシズムの基礎となるパラダイムとしても受け入れられている。現代の建築家が建築環境のコミュニケーションにおける複雑性を高める際に有用なパラメトリシズムのツールや手法，デザインコンセプトは，エコロジカルなパフォーマンス基準に照らし建築形態を最適化するという課題に対しても親和性がある。形態学的な出力変数は，環境的な入力パラメータに対応するようにプログラムすることが出来る。例えば，建物のファサードが一定の時間内に晒される日射強度を描いた日光照射マップのようなデータセットは，日除けシステムの適応変化を調べる際の入力データとなり得る。日除けシステムがファサードを覆うにつれ，各構成要素の間隔や形や向きが，それぞれのファサード上の場所での任意の照射条件に適合すべく徐々に変化するのである。結果，ファサード上の各地点における採光とは相対的に日除けを最適化するような，連続した勾配パターンが得られる。と同時に，この適応変化は建物にオーガニックな美観も与え，周囲環境における建物の方向性をわかりやすく示し，都市環境のより良好な理解とナビゲーションを促す。ファサードの分化された表現は，無関心に閉ざされることなく，その位置についての情報を内包・伝達するものである。そしてこれと同様の明確な適応変化と相関関係の原理が，都市における生命過程の活動・イベントのパラメータに適用される。モダニズムの方向感覚に欠けた一般的な中立性や単調感が退き，パラメトリシズムが持つエコロジカルに適応する説得力に取って代わられるのである。

註1　この建築における社会的機能の定義についての理論的詳述については，年内（2010年）にJohn Wiley & Sons Ltd. より刊行予定であるパトリック・シューマッハの著書『The Autopoiesis of Architecture』のこと。
註2　パラメトリシズムの意図とメリットに関する詳細は以下の書物を参照されたい：
パトリック・シューマッハ「Parametricism: A new global style for architecture and urban design」『Architectural Design』79巻4号，Neil Leach編，AD Digital Cities, 2009年7/8月

Courtesy of Patrik Schumacher

Sheikh Zayed Bridge

1997-2010 Abu Dhabi, United Arab Emirates

Site plan

Structural study: rib

Structural study

Study perspectives

Study: sections

46

Construction site△▽

The UAE has a highly mobile society that requires a new route around the Gulf south shore, connecting the three Emirates together. In 1967 a steel arch bridge was built to connect the fledgling city of Abu Dhabi island to the mainland, followed by a second bridge built in the seventies, connecting downstream at the south side of Abu Dhabi Island. The location of the new (third) Gateway Crossing, close to the first bridge, is critical in the development and completion of the highway system. Conceived in an open setting, the bridge has the prospect of becoming a destination in itself and potential catalyst in the future urban growth of Abu Dhabi.

A collection, or strands of structures, gathered on one shore, are lifted and 'propelled' over the length of the channel. A sinusoidal waveform provides the structural silhouette shape across the channel.

The mainland is the launch pad for the bridge structure emerging from the ground and approach road. The Road decks are cantilevered on each side of the spine structure. Steel arches rise and spring from mass concrete piers asymmetrically, in length, between the road decks to mark the mainland and the navigation channels. The spine splits and splays from one shore along the central void position, diverging under the road decks to the outside of the roadways at the other end of the bridge.

The main bridge arch structure rises to a height of 60 m above water level with the road crowning to a height of 20 metres above mean water level.

UAEは高度な車社会で，ペルシャ湾の南岸沿いに，アブダビ市と他の首長国，特にドバイと北部の首長国を高速道路で結ぶ新しいルートを必要としている。1967年，アブダビ島のまだ発展途上にあった都市を本土に結ぶために鋼鉄製のアーチ型ブリッジが建設され，続いて70年代にアブダビ島南側の下流域を結んで二つ目の橋が建設された。三番目にあたる，この新しいシェイク・ザイード・ブリッジは，最初の橋に近接しており，高速道路システムの発展と完成にとって重要な位置を占める。見通しの良い環境を考えると，橋そのものが目的地になること，アブダビ島の本土先端にあって，将来，都市が成長して行くための潜在的な触媒となることが予想された。アブダビ島への三番目の橋の必要性は，10年前，他の二つの橋，4車線のマクタ・ブリッジと6車線のムッサーファ・ブリッジが首都へのアクセスを提供した時に，既に認識されていた。

一方の岸で寄り合わされたストラクチャーの集合が，上部に持ち上げられ，海峡をつなぐ。波型の湾曲部が，海峡をまたぐ美しい構造のシルエットを浮かび上がらせる。

本土は，橋が地面から現れる「発射台」であり，同時に道路へのアプローチでもある。脊椎構造の両端では通路デッキがキャンティレバー状になっている。鉄骨造のアーチが，巨大なコンクリート造の橋脚から非対称に跳ね上がりながら，本土と航路を結ぶ。脊椎は，岸から中央のヴォイドの位置にかけて分岐して広がりながら，ロードデッキの下から対岸の道路まで到達する。

メインブリッジのアーチ構造は水面レベル上の高さ60mまで持ち上げられており，道路レベルは平均海水面から20mの高さに達している。

Courtesy of Abu Dhabi Municipality

Glasgow Riverside Museum

2004-11 Glasgow, Scotland, U.K.

Construction site (May, 2010)

North elevation

The historical development of the Clyde and the city is a unique legacy; with the site situated where the Kelvin flows into the Clyde the building can flow from the city to the river. In doing so it can symbolise a dynamic relationship where the museum is the voice of both, linking the two sides and allowing the museum to be the transition from one to the other. By doing so the museum places itself in the very context of its origin and encourages connectivity between its exhibits and their wider context.

The building would be a tunnel-like shed, which is open at opposite ends to the city and the Clyde. In doing so it becomes porous to its context on either side. However, the connection from one to the other is where the building diverts to create a journey away from the external context into the world of the exhibits. Here the interior path becomes a mediator between the city and the river which can either be hermetic or porous depending on the exhibition layout. Thus the museum positions itself symbolically and functionally as open and fluid with its engagement of context and content.

Building

The building is conceived as a sectional extrusion open at opposing ends along a diverted linear path. The cross-sectional outline is a responsive gesture to encapsulating a wave or a 'pleated' movement. The outer pleats are enclosed to accommodate the support services and black box exhibits. This leaves the main central space to be column-free and open.

Circulation is through the main exhibition space. Openings are envisaged in the roof and walls as appropriate. It is perceived that there should be views out of the exhibition space. These would allow the visitors to build up a gradual sense of the external context, moving from exhibit to exhibit. All openings would be solar controlled so that total black out could be achieved when required. At the end, with a view of the Clyde and the Kelvin, is the cafe and corporate entertainment space. These also allow access and overflow into the open courtyard. The end elevation is like the front elevation with an expansive clear glass facade. It has a large overhang to reduce solar exposure to the building interior. It will allow expansive views up and down the Clyde.

Landscape

The landscape is designed to direct the activities surrounding the building. A ring of varying stones slabs creates a shadow path around the building. On the west side the hard surface progresses to a soft landscape of grass to create an informal open courtyard space. A line of trees will be added alongside the existing ferry quay to reduce the exposure of this area to prevailing winds. Along the south side and the east, shallow water pool features are used to give continuity with the river at quay level.

〈コンテクスト〉
クライド川と街の発展の歴史はグラスゴー固有の遺産である。敷地はケビン川がクライド川に流れ込む場所にあり、建物は街から川へと流れるように構成できる。そうすることで博物館は街と川のダイナミックな関係を象徴する。博物館は街と川、双方を代弁しながら結びつけ、一方から他方への移行の場となり得る。そうすることで、博物館は、その生まれ育った場所であるコンテクストのなかに自らを置き、その展示品とより広いコンテクストとの結びつきを促進させる。

建物は、先端がクライド川に、反対側の端部が市内に向けて開いたトンネルのような小屋になるだろう。その結果、両側がそのコンテクストに向けて多孔性のものとなる。しかし、一方から他方への接続は、外部コンテクストから離れて展示の世界への旅をつくりだすために建物が方向転換する場である。ここで、内部通路は都市と川の間の仲介役となり、展示構成に応じて、密閉された場所にも多孔性の場所にもなる。こうして、博物館は、象徴的にも機能的にも、そのコンテクストと中身の組み合わせと共に、オープンで流動的なものとして自らを位置づける。

〈建物〉
建物は途中で進路を変える線形の通路に沿って、相対する二つの端部が開き、区分された押し出し成型とみなして構成されている。横断面の輪郭は、波あるいは"ひだをとった"動きをカプセルに包むことへ応答したジェスチャーである。外側のひだは、サポート・サービスとブラックボックスによる展示に対応するために囲まれている。これによって主要な中央空間は無柱のオープン・スペースとして残される。

動線は主要な展示空間の端から端まで通っている。開口部は、屋根と壁の適切な位置にとられ、展示空間の外の眺めの存在を感知することができるだろう。来館者は、展示から展示へと進みながら、外部のコンテクストに対する漸進的な感覚を組み立てて行くだろう。すべての開口部では太陽熱が制御され、必要な時は全面的な暗転が可能となる。クライド川とケビン川が見える終端には、カフェと企業のエンタテイメント・スペースが置かれる。これらのスペースも、開いたコートヤードへ通じ、そこに流れ込む。端部の立面は正面と同じような、大きな透明ガラスのファサードである。ファサードには建物内部への陽射しの侵入を抑えるために広い張り出しが付けられる。そこからはクライド川の上流や下流に広がる眺めが見える。

〈ランドスケープ〉
ランドスケープが建物周囲での諸活動を誘導するようにデザインされる。様々な石のスラブで構成された環が建物の周りに影の落ちる通路をつくりだす。西側に面しては、堅い石の面は草の柔らかなランドスケープへと進み、形式張らない開放的なコートヤードをつくりだす。木々が既存のフェリー埠頭のそばに一列に植えられ、風からコートヤードを守る。南側と東側に沿って、特徴のある浅いプールが、川岸のレベルとの連続性をつくりだす。

Construction site (May, 2010) * Courtesy of Zaha Hadid Architects

Construction site: steel frame (February, 2009) © Hélène Binet

Diagram

1 EVENT SQUARE	8 CLOAKROOM AND RECEPTION	15 EXHIBITION AREA
2 ENTRANCE LOBBY	9 EDUCATION CENTRE	16 DISPLAY STUDY CENTRE
3 MAIN EXHIBITION AREA	10 LOADING BAY	17 STAFF MEETING ROOM
4 WEST GALLERY	11 WORKSHOP	18 STAFF ROOM
5 EXHIBITION STREET NO.1	12 STAFF OFFICE	19 VOID
6 EXHIBITION STREET NO.2 AND 3	13 CAFE	20 PLANT ROOM
7 RETAIL	14 THE GLENLEE	21 STAFF CHANGING AND TOILETS

Ground floor

First floor

Sections

North elevation

South elevation

51

CMA CGM Tower

2006-10 Marseille, France

Distant view (under construction) © Hélène Binet

1 OFFICE
2 LIFT LOBBY

Site plan

Typical floor

The new Head Office tower for CMA CGM in Marseille, France rises in a metallic curving arc that slowly lifts from the ground and accelerates skywards into the dramatic vertical geometry of its revolutionary forms. The disparate volumes of the tower are generated from a number of gradual centripetal vectors that emerge from within the solid ground surface, gently converge towards each other, and then bend apart, towards its ultimate co-ordinate 142.8 metres above the ground. The tower's structural columns define, and are enclosed within, a double facade system that reflect these centripetal vectors, generating a dynamic symbiosis between a fixed structural core of this Head Office and its peripheral array of columns.

Urban Masterplan

Marseille, one of the largest cities in France, is an historic Provencal city centred around the centuries-old harbour, with a rich past of several cultural interventions from Phoenician, to Greek, to the Romans. This fortified city has grown into a cosmopolitan metropolis due to its development into one of the most important international ports in Europe. With the city's distinguished naval history, and the unique siting of the CMA CGM tower beside both the harbour and the major motorway interchange, there is an opportunity to provide a highly visible landmark building to act as a gateway to the city from both land and sea. This new tower would be an iconic vertical element that interacts with the other significant landmarks of Marseille: La Major; the Basilica Notre Dame de la Garde; the Fort St. Jean; and the Chateau d'If.

Urban Strategy

The key challenge for the design of the CMA CGM Head Office tower is the integration of the building environment and the creation of a totally unique, iconic edifice. The current CMA CGM headquarters distinguishes itself with a prominent position within immediate vicinity of the Mirabeau site. Flowing past the site on both sides is an elevated motorway viaduct that bifurcates at the western edge of the new tower's location. At ground level, a major new transport interchange will allow pedestrians to access the new public transport facilities for the this district of Marseille. Whilst the quai and its waterways are also adjacent to site of the new tower. Directly at the confluence of this dynamic urban movement, the new Tower would accentuate its verticality and create a signature feature that would set a commanding new presence.

Taxonomy

The unique design strategy of the new CMA CGM Head Office divides the overall volume into smaller fragments and reassembles them in a manner that maintains the integral uniformity of the tower—but with design elements that encourage the best possible relationship for the tower with the city of Marseille. Detailed exploration and research has created the possibility of a more elegant fluid, sculptural form. The building maintains the regularity in the upper levels whilst the lower portion of the CMA CGM Head Office tower 'morphs' from the vertical to the horizontal to relate to the extreme horizontal energy of pedestrian, automobile, tram and shipping movements at ground level.

The programme of the Tower building has an inherent division that supports this 'morph': the upper floors are much more private office spaces while the lower floors contain public and semi-public spaces that call for a continuous, horizontal arrangement. The lower portion then becomes shaped to allow for more generous accommodation. The supporting columns have also been placed on the exterior envelope to minimize disruption to the office floors, while the curving profiles on the exterior facades work with the central core of the tower providing a rigid frame and giving a sense of movement and freedom to this completely new typology of tower.

Aerial view (rendering)

East elevation

フランス・マルセイユにあるCMA CGMグループの新しい本拠となる高層建築は，湾曲したメタルによって弧を描くように屹立する。これは地上からゆっくりと上昇し，空に向かって加速する躍動的な垂直ジオメトリの革新的形態である。少しずつ中心に向けられた一連のベクトルによって構成された高層建築の二つのヴォリュームは，堅固な地表面から浮かび上がり，お互いが静かにひとつの形へと収束するが，その後は別々の方向に折れ曲がり，最終的には地上142.8mの高さにまで達している。これらの求心的ベクトルを反映したファサード・システムは，柱構造を複層面内に内包し，その面形状を決定している。そこで生み出されるのはこの本社ビルの静的な構造コアと，外周に配列された柱の間の躍動的な共生関係である。

〈都市計画〉
フランス最大の都市のひとつであるマルセイユは，何世紀もの歴史のある港を中心としたプロヴァンスの古都である。ここにはフェニキア，ギリシャ，ローマといった数多くの文化の流入を経た歴史が溢れている。ヨーロッパで最も重要な国際港としての発展を通して，かつての要塞都市は世界都市へと成長してきた。由緒ある港町として，また，港や主要高速道路のインターチェンジのすぐ側というCMA CGMタワーの敷地の特徴という点からも，この計画は陸と海からの表玄関に相応しい，非常に視認性の高いランドマークをつくる恰好の機会であった。この新しい垂直の高層建築はマルセイユを象徴するものとして，マジョール大聖堂，ノートルダム・ド・ラ・ギャルド・バジリカ聖堂，サン・ジャン要塞，イフ島の牢獄など，他の重要なランドマークと呼応するようになるだろう。

〈都市戦略〉
CMA CGM本社タワーの設計における主要課題は，建築環境の統合と，全く新しい象徴としての建築の創出である。現在のCMA CGM本社はミラボー通りからほど近い名の知れた一等地にある。敷地の両側を通り過ぎるのは，新しい敷地の西側の端で分岐する高速道路の高架橋である。地上階では，新しい大規模乗換ターミナルから，歩行者はこの地区を走る新型の公共交通機関にアクセスすることができる。堤防や運河もまた，新しいタワーのすぐ隣に位置している。これらの力強い都市動線が直接合流する地点に建つ垂直性を強調した新しいタワーは，新しい時代の圧倒的な存在感を際立たせるようになるだろう。

〈タイポロジー〉
全体のヴォリュームをより小さな断片へと分割し，マルセイユの町と高層建築の関係性を深める上で最も相応しい建築要素として，これらの断片が再び完全に調和のとれた高層建築へと構成される。新しいCMA CGM本社ビルで採用されたのはそのような独自の設計手法である。詳細にわたる考察と研究は，より気品ある，流れるような彫塑的形態の可能性へと結実した。規則的に連続する上層階とは対照的に，CMA CGM本社ビルは地表面の歩行者や自動車，トラム，船舶などの動線の持つ水平方向の極限的なエネルギーに呼応して，垂直から水平へと「変化」するのだ。

このような「変化」は，このタワーのプログラムに本質的に内在する空間の分離によるものである。上層階にはプライベートなオフィス空間が，一方，下層階には平面的な配置計画を要求する連続的なパブリック，あるいはセミパブリックな空間が含まれている。下層部はこれらを見越してゆったりと計画されている。オフィス・フロアへの侵入を最小限に抑えるために，構造柱は外壁に面して配置されている。その一方で，外部ファサードの曲線的な輪郭は高層建築の中央コアと一体的に機能し，フレーム構造は堅固ながら，このように完全に新しい高層建築のタイポロジーに躍動感や自由を与えている。

Geometrical dependency of various towers' element

Diagram

Sectional perspective: interior

Longitudinal section

Cross section

Structure

55

London Aquatics Centre

2005-11 London, U.K.

57

Surface contours

The architectural concept of the London Aquatic Centre is inspired by the fluid geometry of water in motion, creating spaces and a surrounding environment in sympathy with the river landscape of the Olympic Park. An undulating roof sweeps up from the ground as a wave—enclosing the pools of the Centre with its unifying gesture of fluidity, whilst also describing the volume of the swimming and diving pools.

The London Aquatic Centre is designed to have the flexibility to accommodate the size and capacity of the London 2012 Olympic Games whilst also providing the optimum size and capacity for use in Legacy mode after the 2012 Games.

Site Context

The London Aquatic Centre is situated within the Olympic Park Masterplan. The site is positioned on the south eastern edge of the Olympic Park with direct proximities to Stratford. The new pedestrian access from the east-west bridge called the Stratford City Bridge which links the Stratford City development with the Olympic Park will cross over the LAC. This will provide a very visible frontage for the LAC along the bridge. Several smaller pedestrian bridges will connect the site to the Olympic Park over the existing canal.

The Aquatic Centre addresses within its design the main public realm spaces implicit within the Olympic Park and Stratford City planning. These are primarily the east-west connection of the Stratford City Bridge and continuation of the Olympic Park space alongside the canal.

Layout

The Aquatic Centre is planned on an orthogonal axis perpendicular to the Stratford City Bridge. Along this axis are laid out the three pools. The training pool is located under the bridge whilst the competition and diving pools are within a large volumetric pool hall. The overall strategy is to frame the base of the pool hall as a podium by surrounding it and connecting it into the bridge. This podium element allows for the containment of a variety of differentiated and cellular programmatic elements into a single architectural volume which is seen to be completely assimilated with the bridge and the landscape. From the bridge level the podium emerges from underneath the bridge to cascades around the pool hall to the lower level of the canal side level.

The pool hall is expressed above the podium level by a large roof which is arching along the same axis as the pools. Its form is generated by the sightlines for the spectators during the Olympic mode. Double-curvature geometry has been used to create a structure of parabolic arches that create the unique characteristics of the roof.

Site plan

The roof undulates to differentiate an internal visual separation inside the pool hall between the competition pool volume and the diving pool volume. The roof projects beyond the base legacy pool hall envelope to extend the roof covering to the external areas of the cascades and the bridge entrance. The roof projection over the bridge entrance announces the London Aquatic Centre's presence from the approach from either Stratford City or the Olympic Park. Structurally the roof is grounded at 3 primary positions. Otherwise the opening between the roof and the podium is in-filled with a glass facade.

〈デザイン・コンセプト〉
ロンドン・アクアティック・センター（LAC）の建築コンセプトは，水の動きがつくりだす流麗なかたちに触発されたもので，オリンピック・パークの水辺の風景と調和した空間や周辺環境をつくりだす。起伏する屋根が波のように地上から裾を大きく引いて広がり，センターの各プールをその流れのなかに一つに包み込みながら，水泳プールと飛び込みプールのヴォリュームを表現する。

アクアティック・センターは，2012年のロンドン・オリンピック競技に求められるプールの規模と観客収容能力に適合すると同時に，2012年の競技終了以降の運用にも適切に対応できるよう柔軟に設計されている。

〈敷地のコンテクスト〉
LACはオリンピックパーク全体計画の敷地内に配置される。敷地はオリンピックパークの南東端にあり，ロンドン近郊のストラトフォードの街に直接面している。ストラトフォードの開発地区とオリンピックパークを東西に結ぶストラトフォード・シティ・ブリッジから入る新しい歩行者専用通路が，LACの敷地上に架け渡される。これはブリッジに沿って非常に目立つ正面構成をLACに提供することになるだろう。いくつかの小さな歩道橋が既存の運河を越えて敷地をオリンピックパークへ結ぶ。

LACのデザインには，東西を結ぶストラトフォード・シティ・ブリッジとの接続や，運河沿いのオリンピックパークエリアの延長など，オリンピックパークとストラトフォードの都市計画に内在する主要な公共空間が取り込まれている。

〈配置構成〉
アクアティック・センターはストラトフォード・シティ・ブリッジに直交する軸線上に計画されている。この軸線に沿って，三つのプールが並ぶ。トレーニング用プールはブリッジの下にあり，競技プールと飛び込みプールは大きな容積を持つプール・ホールのなかにある。全体のコンセプトは，プール・ホールの基部を囲み，ブリッジへ連結することで基壇として組み立てることである。

基壇は，差異化され，細分化された様々なプログラム要素を，完全にブリッジと風景に同化しているように見える単一の建築ヴォリュームへと封じ込める。ブリッジ・レベルから見ると，基壇はブリッジの下面から現れ，プール・ホールの周りを段々になって低い運河側のレベルへ下がって行く。

プール・ホールはプールと同じ軸線に沿って弧を描く大屋根によって，基壇レベルの上にかたちを表す。その形態はオリンピック開催中の観客の視線を考えて構成されている。屋根を独特なものとしているパラボリック・アーチを構成するために二通りの曲率が使われた。屋根の起伏は，プール・ホール内の競技プールと飛び込みプールのヴォリュームを視覚的に識別させてくれる。屋根は基部に続くプール・ホールの外皮を越えて突き出し，階段状に広がる外部エリアとブリッジ・エントランスまで覆うように延びる。ブリッジ・エントランスの上に張り出した屋根は，ストラトフォードあるいはオリンピックパーク，どちらの進入路から近づいても，LACの存在を知らしめるだろう。屋根は，構造上，三つの主要な位置で設地している。それ以外は，屋根と基壇の間の開口はガラスのファサードで満たされる。

Olympic mode: competition pool (right) and diving pool (left)

Legacy mode

△▽ © Hélène Binet Construction site △▽

Ground floor

First floor

Elevations

Cross section

Sectional detail: through northern plaza

Elevation at main entrance and roof

Cross section AA

Longitudinal section

63

MIDDLE EAST CENTRE, ST. ANTONY'S COLLEGE

2006- Oxford, U.K.

View from west

West elevation S=1:400

View from southeast

North elevation

South elevation

The Middle East Centre of St. Antony's College is the University of Oxford's centre for interdisciplinary study of the Modern Middle East. The centre was founded in 1957 and it is focused on research on humanities and social sciences with a wide reference to the Arab World and its geographic adjacencies. The Centre's research core is a specialised library and substantial paper and photographic archive covering material from 1800's onwards. At present, the Middle East Centre's Library and Administration facilities are housed in the former Rectory of the Church of SS. Philip and James at 68 Woodstock Road. The archive is housed in the basement of the neighbouring property at 66 Woodstock Road, sharing the building with other facilities and rooms of the college. The Middle East Centre also had 3 workrooms in the same property. To tie in with the St. Antony's College future plans the Middle East Centre is planning a new Library and Archive to meet the current use for research and academic activities.

Zaha Hadid Architects has been commissioned to design a scheme in the garden plot that separates 68 and 66-64 Woodstock Road. The new building has to comply with the college's vision for growth and add formal coherence to the existing quad, and tie in with the ambition ADP's masterplan for St. Antony's college.

The new building will allow for a less restrictive research environment and a much better link between the academic aspect of the institute and its social function. The strong physical constraints and the scale of the site demand a different approach to linking both 68 and 66 Woodstock Road, where the architecture turns into itself, morphology of dynamic tensions visibly restricted by material boundaries. These last points of reference allow for abstracting use from the current landscape, employing the current topography to mark programme activities and separate public from private functions. Our approach is to define a series of plateaus and territories where different academic and research affiliations can be apparent from the character of the interior space. Form is driven by a series of tension points spread on a synthetic landscape that blends built and natural elements.

The new structure deforms and adapts to this new abstract environment, revealing paths and flows, whilst containing the more introvert aspects of the programme brief. The new bridging form allows for programme connection at different levels, gradating space in relation to the public/private dichotomy. The intention is to create a suspended structure that allows for the more public aspects of the brief to infiltrate the building and spill into the college's curtiledge facing the Hilda Bess building. This is a flexible territory where space is layered through contrasting use of built elements and materials.

聖アントニー・カレッジの中東研究所は，オックスフォード大学に付属する，近現代における中東に関する協同研究の拠点である。研究所は1957年に設立され，アラブ諸国や周辺諸国の人文科学や自然科学の研究を行っている。研究所の核となるのは，専門的なライブラリーと1800年代以降をカバーする文献や映像資料のアーカイブである。現在，中東研究所のライブラリーと管理部門はウッドストック通り68番地にある，かつての聖フィリップ・聖ジェームス教会の司祭館にある。アーカイブはその他の大学施設と共に，ウッドストック通り66番地に位置する建物の地下部分に収められている。同じ建物内には，他に三つのワークルームがある。聖アントニー・カレッジの将来的なプランにも対応できるように，中東研究所は研究および学術活動に使用される新たなライブラリーとアーカイブを計画する。

我々はウッドストック通り68番地とウッドストック通り66～64番地を隔てる敷地の中庭についての計画案を依頼された。新たな建物は，大学が目指す将来のビジョンに応えるとともに，聖アントニー・カレッジの既存の中庭に統一感を持たせなければならない。

新たな研究所は，制約の少ない研究環境を生みだすと同時に，研究所の学術的側面と社会的機能をより強く結びつけるだろう。物理的制約と敷地のスケールを考慮すると，ウッドストック通り68番地と66番地を結びつけるには通常と異なるアプローチが求められる。このポイントで，この建物自体が，素材の境界が視覚的に定める動的な張力により生まれる形態へと変容する。このようにして，現状のランドスケープを抽象化し，そこからプログラムやアクティビティを明確化し，プライベートとパブリックな機能を分離することができる。我々は，異なる学術・研究分野が室内空間の特徴から明確にわかるように，プラトーとテリトリーの連続する連なりとして定義した。人工と自然のエレメントを一体化した，人工的なランドスケープ上の張力のポイントから形態を導いている。

新たな構造は，人の通りや流れを明確化し，プログラムの内在的要素を包み込みながら変形し，この新たな抽象的環境に適応していく。ブリッジ状の新たな構造体は，異なるレベルに渡ってプログラムの繋がりをつくり，パブリックとプライベートという二項のバランスに応じて空間を段階分けする。よりパブリックな要素を建物内部に浸透させながら，同時にヒルダ・ベス・ビルディングに面したカレッジの敷地にも展開させるため，吊り構造を採用した。さらに既存の建築要素や材料を対比的に用いることにより，空間が重層的に重なったフレキシブルな場を目指している。

Longitudinal section 1 S=1:500

1 LIBRARY READING ROOM
2 ARCHIVE READING ROOM
3 LIBRARY ROLLING STACK BOOK STORAGE
4 ARCHIVE ROLLING STACK STORAGE
5 AUDITORIUM
6 LOBBY/ CAFE / GALLERY SPACE
7 RESTROOMS
8 LIBRARY IT ROOM
9 PLANTROOM

Longitudinal section 2

Longitudinal section 3

Cross section 1 S=1:500

Cross section 2

Cross section 3

Cross section 4

Cross section 5

Longitudinal section 4

Cross section 6

West side

Library

Hall

Second floor

1 LIBRARY READING ROOM
2 LIBRARY ROLLING STACK BOOK STORAGE
3 LIBRARY IT ROOM
4 ARCHIVE READING ROOM

First floor

Heydar Aliyev Cultural Centre

2007- Baku, Azerbaijan

Exterior skin panels analysis

Diagram: cores (left) and overall structure (right)

The Heydar Aliyev Cultural Centre will give the city of Baku, Azerbaijan a major new venue and landmark building for the city. The Cultural Centre will house a conference hall with 3 auditoriums, a library and a museum.

Site Strategies

This ambitious project will play an integral role in the intellectual life of the city. Located close to the city centre, the site will play a pivotal role in the redevelopment of Baku. The site neighbouring the Heydar Aliyev Cultural Centre is designated for residential, offices, a hotel and commercial centre, whilst the land between the Cultural Centre and the city's main thoroughfare will become the Cultural Plaza—an outdoor piazza for the Cultural Centre as well as a welcoming space for the visitors.

Design

The proposal for the Heydar Aliyev Cultural Centre envisions a fluid form which emerges by the folding of the landscape's natural topography and by the wrapping of individual functions of the Centre. All functions of the Centre, together with entrances, are represented by folds in a single continuous surface. This fluid form gives an opportunity to connect the various cultural spaces whilst, at the same time, providing each element of the Centre with its own identity and privacy. As it folds inside, the skin erodes away to become an element of the interior landscape of the Cultural Centre.

The Museum faces out into the landscape—participating in the urban fabric of the city developing around the site. Its glass facade is slightly interrupted with the sculptural interplay between the outer skin and the ground. The interior is an extension of the natural topology of the site with the glass facade flooding the Museum in natural light. The ground surface of the Museum begins to fold and merges to the outer skin which allows the new extension to become part of the topography of the site, whilst ramps connect the ground floor with the mezzanine levels above.

The Library faces north for controlled daylight and has its own entrance on this elevation. The reading and the archive floors are stacked on top of each other, and wrapped within the folds of the outer envelope. The floors fall to each other with ramps connecting them, creating a continuous path of circulation. The Library and the Museum are also connected by a ramp that leads through the ground floor of the Library to the first floor of the Museum. Additionally, the Library is connected to the Conference Hall via a bridge that 'flies' through the Library's entrance foyer.

The Conference Hall accommodates 3 auditoriums of different sizes. Its form leans into the Cultural Plaza to create the necessary inclination for the seating. All three auditoriums and their associated facilities have a direct access to the Plaza. The main entrance is located in the void created by the outer skin being 'stretched' between volume of the Museum and the Library tower. A secondary entrance is situated on the north side of the building.

Landscape

The landscape emerges from the ground to merge with the building. This rippling, manifest as earth mounds, fades as it moves away from the main building to radiate like waves. The building itself also merges into the landscape to become the Cultural Plaza—further blurring the boundary between the building and the ground. These landscape formations also direct the circulation of visitors through the building and Cultural Plaza, where outdoor activities and performances take place.

ヘイダル・アリエフ文化センターはアゼルバイジャンのバクーに新しい主要な施設とランドマークを提供する。文化センターは三つのオーディトリアムを持つカンファレンス・ホール，図書館，美術館を内包する。

〈敷地計画〉

この野心的なプロジェクトは街の知的生活において不可欠な存在となる。市街地に程近く，バクーの再開発において重要な役割を担う。ヘイダル・アリエフ文化センターの周りには住宅地や，オフィス，ホテルおよび商業施設が計画され，文化センターと街の目抜き通りの間が文化プラザとなり，文化センターの屋外広場および訪問客を迎える空間として機能する。

〈デザイン〉

ヘイダル・アリエフ文化センターの計画案は，ランドスケープの自然な地形を折り曲げ，センターの各機能を包み込む，流れるような形態を目指している。エントランスを含むセンターの全機能は，連続する表皮を折り曲げることで表現されている。この流動性のある形態は，多様な文化的な空間を結ぶと同時に，センターの各部分に独自のアイデンティティとプライバシーを与えている。建物の表皮は内側に折れ曲がると，センター内のランドスケープの一部となるべく浸食を始める。

美術館は外部のランドスケープに向かって開かれ，敷地周辺で発展する街の都市機能と一体化している。ガラスのファサードは，表皮と地面が作り出す造形によって一部が侵食されている。ガラス越しの自然光で満たされる内部は，自然の地形の延長にある。美術館の地面が折れ曲がりそのまま表皮へと変化することで，新たな延長部分は敷地の一部となり，その上部ではスロープが地上階と各メザニン階を連結している。

図書館は日光を制限するため北に対して開かれ，独立したエントランスを持つ。読書室を収めた階とアーカイブの収まる階は上下に重ねられ，折れ曲がった表皮によって包まれている。各階はそれぞれを繋げるスロープへ向かって下降しており，連続する動線をつくり出している。図書館と美術館は，図書館の地上階から美術館の1階へと続くスロープによって連結されている。さらに，図書館エントランスのホワイエを「浮遊する」ブリッジによって，図書館とカンファレンス・ホールは繋がっている。

カンファレンス・ホールには三つのオーディトリアムがあり，それぞれ異なる大きさになっている。その形は文化プラザ側へと傾き，聴衆席に必要なスロープを確保している。三つのオーディトリアムとそれに付随する施設からは全て，プラザへ直接アクセスできる。メインエントランスは，美術館と図書館タワーの中間で引き伸ばされた表皮が作り出すヴォイド内部にある。二次的なエントランスは建物の北側へと配置された。

〈ランドスケープ〉

地面は建物と一体化するようなランドスケープを形成する。土塁として表現されている波紋は，メインの建物から放射状に離れるにしたがって小さくなる。建物もランドスケープと一体化し，文化プラザとなり，建物と地面の境界がさらに曖昧になっている。このようなランドスケープの構成は建物内および文化プラザにおける訪問者の動線をつくり，外部での催しやパフォーマンスを可能にする。

Southwest elevation

Southeast elevation

Site plan

Level 2

Ground level

Level 1

Longitudinal section

Cross section

73

Cafe

Museum gallery

Auditorium

Auditorium entry

Space frame (construction site)

Space frame (construction site)

Slabs

Space frame (construction site) △▽

Topological analysis: building envelope

* *Courtesy of Zaha Hadid Architects*

77

Museum in Vilnius

2007- Vilnius, Lithuania

The creation of the new centre of contemporary and media art in Vilnius is part of a feasibility study undertaken by the Solomon R. Guggenheim Foundation and The State Hermitage Museum. It will be a critical element of the cultural life of the city; complementing the existing programmes Vilnius has recently developed for contemporary art.

The design points towards a future architectural language that is part of an innovative research trajectory within Zaha Hadid Architects; embracing the latest digital design technology and fabrication methods to enables a seamless transfer of Zaha Hadid Architects' characteristic acceleration curves and sculpted surface modulations from drawing board to realization.

The museum's sculptural volume is designed with the conceptual terms of fluidity, velocity and lightness. The building appears like a mystical floating object that seemingly defies gravity. Curvilinear lines echo the elongated contours of the building, offering an enigmatic presence that contrasts with the vertical skyline of Vilnius' business district. It is a manifestation of the city's new cultural significance.

Site plan

ヴィリニュスにおける現代美術とメディアアートのための新美術館の建設は，ソロモン・R・グッケンハイム財団と国立エルミタージュ美術館によって実施されたフィジビリティ・スタディの一環によるものである。現代美術のため，近年ヴィリニュスで展開されている既存のプログラムを補完するものとして，この建築はこの都市の生活や文化にとって欠くべからざるものになるだろう。

この計画は，建築家の先進的な研究の軌跡の一端として，新しい建築言語の実現を指向したものである。最新のデジタル・テクノロジーによる設計・製作過程は，我々の特徴である加速する曲線や表層の彫塑的抑揚を図面から現実へと滑らかに移行することを可能にしている。

美術館の彫刻的ヴォリュームは，空間の滑らかさ，速度，軽さといった抽象言語で計画されている。建築は，あたかも重力を無視して神秘的に漂う物体のように見える。曲線が建築の長く伸びた輪郭と呼応して，ヴィリニュスの商業地区の垂直的なスカイラインとは対照的に謎めいた佇まいを見せる。この建築は，この都市の新しい文化的意義に対する意思表示である。

Level 0

Level -1

Level 2

Level 1

1. ENTRY
2. LOBBY
3. BIG THEATER
4. SMALL THEATER
5. SHOP
6. SPECIAL EXHIBITION (double height)
7. SPECIAL EXHIBITION (triple height)
8. CAFE
9. MEDIA CENTER
10. CORE COLLECTIONS
11. EDUCATIONAL CENTER
12. 'LITVAK' EXHIBITION
13. OFFICE
14. 'HERMITAGE' EXHIBITION
15. RESTAURANT
16. LOADING/UNLOADING
17. STORAGE

Plan

Lobby

Section AA: through special exhibition, lobby, and entrance

Section CC: through lobby

Litvak exhibition

Special exhibition

Hermitage exhibition

Regium Waterfront

2007-　Reggio Calabria, Italy

The project aims to define the city of Reggio Calabria as a Mediterranean cultural capital through the realization of two characteristic buildings: a museum and a multifunctional building for performing arts.

The location of the site on the narrow sea strait separating continental Italy from Sicily, offers an opportunity to create two unique buildings visible from the sea and the Sicilian coast: a Museum of the Mediterranean History and a Multifunctional Building.

The form of the museum draws inspiration from the organic shapes of a starfish. The radial symmetry of this shape helps to coordinate the communication and circulation between different sections of the museum and its other facilities. The Museum of Mediterranean History will house exhibition spaces, restoration facilities, an archive, an aquarium and library.

The Multifunctional Building is a composition of three separate elements that surround a partially covered piazza. The building will house the museum's administrative offices, a gym, local craft laboratories, shops and a cinema. Three different auditoriums, which can be converted into one large space, are also housed in the Multifunctional Building.

Site plan　S=1:20000

この計画は，博物館と，舞台芸術のための複合施設という二つの特徴的な建築の実現を通して，レッジョ・ディ・カラブリアの町を地中海地方の文化的中心地として定義することを目的としたものである。

敷地はイタリア本土とシチリア島を隔てる幅の狭い海峡に面しているため，地中海歴史博物館と複合施設棟という二つの特徴ある建築を，海や対岸のシチリア島から見渡すことができる。

博物館棟の形態は，ヒトデの有機的な姿からインスピレーションを受けたものである。放射状で対称形の姿は，博物館や他の施設の異なるセクション同士の交流や動線の循環の統合を促している。地中海歴史博物館が収容するのは，展示空間，資料修復室，収蔵庫，人工池，および図書館である。

複合施設棟は，部分的に屋根の架かった広場を取り囲む独立した3棟の建築要素によって構成されている。この建築には事務管理室，スポーツジム，地元工芸品の研究室，店舗，および映画館が収容される。ひとつの大空間としても使用可能な三つの独立したオーディトリウムも，複合施設棟に収容される予定である。

Multifunctional building　S=1:4000

Museum　S=1:4000

Multifunctional Building

Skin

Multifunctional Building

WING 2

WING 1

Skin

Level 0 S=1:2400

WING 1 WING 2

WING 2 WING 1

Elevations S=1:1600

86

Wing 1: longitudinal section S=1:700

Wing 1: cross sections S=1:700

Wing 2: longitudinal section S=1:700

Wing 2: cross sections S=1:700

Museum

Percorso matrice

Percorso espositivo

Museo + acquario

Biblioteca

I percorsi pubblici

Circulation diagram

Museum

Roof

Second level

First level

Ground level

Elevations S=1:1600

Sections S=1:1000

New Beethoven Concert Hall

2008-09 Bonn, Germany

West elevation

South elevation

East elevation

North elevation

Aerial view from southeast

East side: floating performance area on Rhine River

Level 1 (mezzanine)

Site plan

Level 1

Level 3

Diagram: circulation of visitors

Level 0

Level 2

94

Section AA

Section BB

Section CC

Section DD

Section EE

Urban Concept

A central priority in ZHA's urban design concept for a new Beethoven Festival Hall is linking the city of Bonn to the Rhine River promenade and leveraging that idea's potential to enrich public life on the river's edge.

Learning from the missed opportunities during the planning of the existing building in the 1950's, ZHA's proposal not only incorporates a high degree of porosity in its site plan, but intensifies the connection by introducing a transparent "Rhine Foyer" into the building mass; a dramatic atrium that stretches from the City to the Rhine. With two main facades, the building presents itself in an open and inviting manner to the River and the City, allowing for deep visual links through its crystalline mass. The light Rhine Foyer will make audiences and performers feel comfortable and relaxed but simultaneously excited by the anticipation of a unique experience.

Site circulation can take place uninterrupted through various levels inside and around the building. Artificial landscape formations lead from inside the building to terraced outdoor areas, interweaving the elevated foyer levels with surrounding exterior plateaus. The stepped topography on the Rhine invites Bonn residents and visitors to informally enjoy outdoor performances.

The main public route is a large diagonal passage, an "erosion," running from the city through the Rhine Foyer and down a large exterior staircase to the river promenade. The promenade is sliced into curvilinear seating that gently step down to the Rhine, facing a seasonal floating performance area on the water's edge. Illumination from within the foyer, embedded in the ground, and floating in the water will change the character of the site and building during evening performances. The building becomes a performer itself. The new Beethoven Symphony Hall will be an icon for the city of Bonn and a living monument to Beethoven. A European jewel!

Form

Sculpted Exterior

A jewel is placed on the Rhine riverbank. Its faceted external surface oscillates between crisp edges, like a crystalline rock formation, and rounded areas where large openings occur. Dynamic perforations wrap the volume, allowing for a gradient of light conditions throughout the building. At night, the object turns transparent, glowing from the inside.

Polishing and Smoothing

The volume's exterior surface is articulated through a series of planar cuts. A crystalline surface tessellation results from the applied operation of cutting and sharpening, as well as smoothing and polishing.

Some planes are further subdivided with a smaller secondary pattern that allows for a porosity and transparency inside the building. This pattern is based on components

Large auditorium: translucent reflector

Large auditorium: opaque reflector

that follow the morphology of the building as a whole. Variations within the pattern provide a visual rhythm that both differentiates and unifies the facade.

Inlays

The large wooden symphonic hall is inlayed like a musical instrument's resonating body within the exterior envelope, faintly expressing itself towards the outside. A warm glow resonates from within. The formal counterpoint to the large hall is constituted through the smaller recital and chamber music hall.

The large concert hall and the smaller recital hall are wrapped in their own skins in such a way that both volumes appear subtly through the exterior envelope. Both volumes are shaped by their internal acoustic logics in order to provide a world class musical experience, while finer interior modulations are introduced to provide atmospheric qualities that enhance visitor experience and performance requirements.

In this way, the shape of the two halls is translated into a more fluid continuum of lines and surface patterns on their skins. Visitors can experience both volumes simultaneously from various viewpoints on different levels in the building's lobby. The Rhine Foyer space might evoke the impression of being in a river valley surrounded by rock erosions on opposite river banks.

Carved out Interior

The 'Rhine Foyer' with its curvilinear characteristics can be perceived as an in-inversion of the external facets. The enhancement of public and cultural life within this carved out passage is what is aimed for in this scheme. The experience of music on an experimental and possibly less formal level within this canyon space would attract visitors beyond the activities taking place within the concert and chamber music halls.

At certain access points as well as at large glazed openings, the building's convex shape shows concave indentations. These "in-inverting" operations mark special points of perception or visitor flow. Formal devices become orientation devices and support navigation through the site.

Artificial Landscape

At various points, surfaces fold from the building into the landscape and continue the surface tessellation on the ground. The concert hall's crystalline form is echoed in the artificial landscape's modulations.

On the Rhine, large terraces stretch out like rocks, ramping down from the lobby into the park facing the Rhine. Similarly, certain landscape features extend into the building's lobby to provide the interior with the same formal and spatial logic as the surrounding land formations.

アーバン・コンセプト

ボンの街とライン川沿いの遊歩道を繋げることが，新ベートーヴェン・コンサート・ホールにおけるアーバンデザインコンセプトの中核をなす。このアイディアの可能性を最大限に引き出すことで，河岸における公共生活を豊かにすることを目指した。

1950年代に建てられた既存の建物では考慮されなかった高密度の多孔性を敷地に取り入れるのみならず，透明な「ライン・ホワイエ」を建物のマッスへと挿入することで，その繋がりをより際立たせた。このホワイエは，街から河へと延びる劇的なアトリウムである。メインとなる二つのファサードにより，建物は街と河へと開かれ，人々を招き入れる。その水晶を彷彿とさせるマッスにより視覚的な繋がりを一層深めている。軽さを帯びたライン・ホワイエは，観客および出演者をゆったりと心地よくし，思いもよらない場面を予感させることで，気分を高揚させてくれる。

敷地との動線はあらゆる高さで，建物の内外で妨げられず確保されている。人工的なランドスケープの形状が建物内部から階段状の外部エリアへと伸び，内部のホワイエと外部の台地を結び付けている。ライン川沿いの階段状の地形はボンの市民や訪問者をインフォーマルな屋外パフォーマンスへと誘う。

主要なアプローチは，「侵食」と呼ばれ大きな斜めに走る通路で，街からライン・ホワイエを抜け，大きな外部階段を下降して川沿いの遊歩道へと続く。この遊歩道は薄くカットされ，ライン川へとゆっくり下って蛇行する台座となり，そこから水辺に浮かぶ季節限定の舞台を望む。ホワイエ内，そして地面や水面に光を灯すことで，夜間のパフォーマンス時における敷地と建物の表情に変化を与える。建物自体がパフォーマーとなるのだ。この建物はボンの象徴となり，ベートーヴェンに捧げる生きたモニュメントとなる。ヨーロッパの宝石なのだ！

フォルム

〈彫刻的外観〉

宝石はライン川河岸に配置された。この多面的な外部表皮は，水晶のように尖ったエッジと，大きな開口部にある丸みを帯びた部分とが交互に現れる。ダイナミックな穿孔が建物全体を覆いつくし，建物内部に様々な光のグラデーションを演出する。夜には，このオブジェは透明となり，内部から発光する。

〈磨いて滑らかにする〉

建物のヴォリュームは幾つかの面の切り取りによって明確に表現されており，この水晶の表面がつくり出すモザイクは，切り取り，削り，および磨いて滑らかにすることによってつくり出されている。幾つかの面は，更に2次的な細かいパターンへと分割され，建物内部に多孔性および透明性を提供している。このパターンは建物全体の形態を構成する要素を基にしている。パターンの多様性はファサードにリズムを与え変化と統一性を同時につ

Study: early models

FORMAL EVOLUTION

VERTICAL RADIUS EXTENDED 1 EVEN BLEND 1 EVEN SMOOTH WEB 1

EVEN BLEND 2 EVEN SMOOTH WEB 2 VERTICAL BLEND 1

VERTICAL BLEND 2

Study: formal evolution

White pattern: a maximum amount of openings
Black pattern: a minimum amount of openings

Study: unfolded facade pattern

Study: facade pattern, east view

Study: perforation

Facade detail visualisations

**PANEL GRID SIZE
2 METER X 2 METER**

DEFINITION OF 11 DIFFERENT WINDOW OPENINGS

DIFFERENT DENSITIES WITHIN THE WINDOW MATRIX

Facade pattern

Study: facade

くり出している。
〈埋め込み〉
木で覆われた大シンフォニー・ホールは，楽器の共鳴胴のように，外部表皮の中に埋め込まれており，静かに外部へ向けて語りかける。温かみのある光が内側からもれる。この大ホールと形態的に対になるのは，小さな室内楽団用のリサイタル・ホールである。

　大ホールと小リサイタル・ホールはそれぞれ別の表皮で覆われており，外部表皮を通して控えめに表現されるように配慮されている。それぞれのヴォリュームは内部の音響効果を考慮してつくられ，世界基準の音楽体験を提供する。さらにそれぞれの内部空間で用いられた繊細なモジュールは，観客の空間体験と音響の必要条件をより際立たせることを目的とした。このようにして，二つのホールの形態はそれぞれの外皮のさらに流れるように続く線や表面のパターンへと変換された。訪れた人たちは，ロビーのあらゆる高さから，このヴォリュームを同時に見ることが出来る。ライン・ホワイエは対岸の浸食された岩に囲まれた，川の底にいるような印象を髣髴とさせるだろう。

　「ライン・ホワイエ」の曲面は外部の多面性の内と外における反転と捉えられるだろう。この曲線通路におけるパブリックな文化生活の向上こそが，この案で求めたことであった。この峡谷のような空間における，実験的であまり形式的でない音楽体験はコンサート・ホールおよびチャンバー・ホール以外でのイベントにも訪問者の注意を引くことになるだろう。

　特定のアクセスポイントや大きなガラスの開口部においては，建物の凸状の形態に凹状の切れ込みが入っている。この「内と外における反転」は視覚的にも人の流れにおいても特別な地点をつくりだす。この形態操作によって，方向性を与え敷地内を統合することが出来る。
〈人工的なランドスケープ〉
幾つかの地点には，建物の外皮が折れ曲がりそのモザイク模様がひと続きにランドスケープの地面へと変化している。コンサート・ホールの水晶のような形は人工のランドスケープのモジュールとも共鳴している。ライン川に向って，大きなテラスが岩のように伸びており，ロビーからラインを臨む公園へ向ってスロープが下降している。同じように幾つかのランドスケープの特徴は，ロビーへも続いており，外部と同じ形態および空間構成を内部にも与えている。

King Abdullah II House of Culture & Art

2008– Amman, Jordan

West side with public plaza

Diagram: concept

Night view

Grand galleria

101

1 MAIN THEATRE
2 SMALL THEATRE
3 ATRIUM VOID
4 GRAND GALLERIA
5 VIP DROP OFF
6 MAIN ENTRANCE
7 LOADING ACCESS
8 OPEN AMPHITHEATRE
9 PUBLIC DROP OFF

Second floor

1 MAIN THEATRE
2 TICKET HALL
3 ATRIUM VOID
4 GRAND STAIR
5 LEARNING CENTRE
6 MAIN ENTRANCE
7 LOADING ACCESS
8 OPEN AMPHITHEATRE
9 PUBLIC DROP OFF

Ground floor

Longitudinal section

Urban Concept
The urban strategy pursues the maximization of open public space on the western side of the site where Princess Basma Street meets with Ali Bin Abi Talib Road. The mass of the new building is therefore pushed deep into the eastern extension of the site. The elongated volume of the new building is roughly equivalent to the building volume that occupies the site now, but the volume is pushed eastwards to clear the wider western end of the site for sake of creating a big public plaza.

This plaza is important to activate the site and the new institution. It is also important as an appropriate take off point (or point of termination) for the GAM strip. We are proposing a generous, diagonal underpass that emerges in the great plaza as a grand connective gesture.

The urban intentions that are emphasized with the placement of the building volume are further pursued and complemented with the articulation of this volume. The volume is opened up in north-western direction to communicate with the public plaza. This large, inviting opening is pushed all the way through the building to connect with the south side. This cut communicates diagonally in both plan and section and thus accommodates to the topography. The internal void also opens up to the roof. Thus animating the fifth facade of the building. This is important for a primary cultural building that is placed within the central valley of Amman. At night the glowing, festive interior space will be visible from all around.

Architectural Concept
The architectural expression for the new performing arts centre has been inspired by the uniquely beautiful monument of Petra. As an artificial oasis and sanctuary the ancient city of Petra is an appropriate source of analogy for a performing arts centre that aspires to be an oasis and sanctuary for contemporary culture.

Petra is also a fantastic example of the wonderful interplay between architecture and nature. Contemporary architecture is striving to emulate nature and imbue architecture with the intricate complexity and elegance of natural forms. In Petra we admire the way the rose-colored mountain walls have been fissured, eroded, carved and polished to reveal the strata of sedimentation along the fluid lines of the fluvial erosions.

We are applying the principle of fluid erosion and carving to the mass of the building for the performing arts centre. This principle of erosion is the sole means of articulating the public spaces in the building. There can be no doubt that this inviting design will wash away the threshold anxiety that sometimes is felt in front of monumental cultural buildings. While the erosion creates the public foyer spaces the remaining mass represents the performance spaces.

The shape of the eroded space reveals the two main performance spaces as the figurative parts of the eroded mass. The big Concert Theater is exposed at the end of the public void. The Small Theater is exposed overhead at the front of the building where the public foyer space fuses with the public plaza. These two recognizably shaped volumes that contain the primary event spaces are then encapsulated by the support functions to create the exterior cubic volume. However, this exterior volume is not a rigid box. The volume is given tension by letting it gently swell—like the entasis of a column—in response to the public void in the centre of the building. Another nuance is to be noticed with respect to the treatment of the ground-surface—both on the plaza and within the public foyer. The plaza ground outside receives the underpass coming from the GAM strip and thus creates an amphitheatre-like valley. The surface of the plaza rises gently as it approaches the building. The foyer ground is thus slightly raised and dips again slightly in response to the Small Theatre. The ground is eroded again in front of the big Concert Theater to reveal and give access to this performance space creating another situation that might become a kind of amphi-theatre within the overall space.

Such quasi-topographic manipulations of the ground surface are very communicative. They help to structure the large public surface and facilitate orientation and overview, in particular if the space is filled with people. Thus this play with the ground plane goes hand in hand with the overall ambitions of the multi-level public void that allows the audience to participate in the unified public space on many levels. In particular the second, elevated foyer level that connects across to the south-side of the valley might become Amman's favorite spot to relax and enjoy the city.

Functional Organisation
The main access to the building is via the public plaza where the flows from the bus station and from the GAM strip converge. Here we also locate the drop off area. These main flows are taken into the structure through the main plaza entrance leading directly into the grand interior. The interior square opens to the public at daytime, serving as a shaded gathering area, a interior plaza for information, ticket vending and public exhibition. From here the theatres are entered via small buffer foyers.

The second entrance on the elevated south side of the building is used as a VIP entrance with a drop off point directly at the door. The artists and staff entrance is located at the east side of the building. Here a green room and artist's cafe is welcoming all those who actively contribute to the creative life of the institution. On this end of the building—around and above the artist's room and right behind the back-stage—all the support spaces for the artists are located. On this side we also allocated the entrance ramp for the service vehicles that move underground along the south edge of the site to service the two theatres. The service vehicles remain hidden until they exit the site inconspicuously towards Princess Basma Street.

Along the south-side runs a continuous spine with service and support spaces. On the higher levels the public void erodes this service wall to make space for further public circulation and for the big window looking out south.

On the western side of this back-spine, above the main entrance, we have allocated all the educational facilities. They are conveniently accessed via lift and stairs from the main entrance.

Vehicular Access
The access to the underground parking is located to the north side of the plot. This access also serves for deliveries. Furthermore, we propose separate drop-off areas for the existing villas, the hotel and the apartments.

Theatre

△▽ *Grand galleria*

〈アーバン・コンセプト〉
現在，敷地の西側に位置する屋外のパブリックスペースを最大限広げることが都市計画で推し進められている。そこはプリンセス・バスマ通りとアリ・ビン・アビ・タリブ通りが交差する場所である。その為，建物全体は敷地の東側へと押しやられた。新しい建物の細長いヴォリュームは，既存建物のそれとほぼ同じではあるが，西側を開き，広いパブリックな広場を確保するためさらに東側へと配置された。

この広場は，この場所と施設を活性化するために重要な役割を担う。さらにGAM大通りの起点（および終点）ともなる重要な場所となる。我々は敷地を斜めに走る幅広の地下道を提案しており，それは広場が出口となり視覚的な繋がりを見せる。

建物の配置によって強調された都市デザイン的な試みは，ヴォリュームを操作することにより更に推し進められ相互に作用しあっている。このヴォリュームを北西向きに開くことで，広場との対話を図っている。人を招き入れるような大開口部は押しだされるように南側へと繋がっている。ヴォイドは，平面および断面において斜め方向の流れをつくり，敷地の地形にも対応している。このヴォイドは屋根へと続き，五つ目のファサードを強く表現している。このような特徴は，アンマンの谷間に建てられた文化施設として，非常に重要な要素を占める。夜には，光に溢れ賑やかな内部を，あらゆる方向から眺めることが出来る。

〈建築コンセプト〉
新しい劇場の建築デザインは，特徴ある美しいペトラの遺跡からヒントを得た。人工的なオアシスおよび聖域としてのペトラは，現代文化において同様の役割を担おうとするこの劇場とのアナロジーとして，デザインのモデルになるのにふさわしいと考えられた。

ペトラも建築と自然が美しく融合する最良の例である。近年における建築は自然を手本とし，自然の持つ複雑で優美な形を建物に吹き込んでいる。ペトラにおける，ピンク色の山肌が裂け，風化し，彫り込まれ，磨きあげられた様に感銘を受けた。それによって，川に侵食され，うねる様な地層を出現させている。我々は侵食と彫刻が作り出す曲面の原理を劇場のデザインへと適応させた。この原理は建物のパブリックスペースを統合している。このような魅力的なデザインにすることで，通常モニュメント的な文化施設を前にすると感じる威圧感を取り払う事ができる。この侵食がパブリックスペースとなるホワイエを作り出し，残りのスペースが劇場となる。

侵食が作る空間は，二つの劇場スペースを侵食されたマッスの造形的な部分として出現させる。大コンサートホールはヴォイド端部に位置している。小さな劇場は，ホワイエと外部広場が一体となる建物の正面にあり，むき出しの状態で頭上にせり出している。主要空間を内包するこの特徴的なふたつのヴォリュームは，その他の機能を内包する空間によって包まれ，それにより外形の箱が出来ている。しかしながら，この建物はただの箱ではない。広場とホワイエの上で，円柱のエンタシスのように，ヴォリュームがゆっくりと膨れ上がるように引っ張られている。これは建物中央部に位置するヴォイドと呼応している。もう一つは，広場とホワイエの床の表面処理にも現れている。広場の地面には，GAM大通りから続く地下道が顔をだし，円形劇場のような谷が形成される。建物に近づくにつれ，広場の地面はゆっくりと上昇する。ホワイエの床面は僅かに上昇し，小劇場と連動しまた僅かに下降する。床面は大コンサートホールの前でさらに侵食され，コンサートホールへのアクセスを視覚的にもつくり出し，この大空間のなかで円形劇場的な場所を演出している。

このように地形を操作するように床面を扱うのは極めて有効である。これらは大きな，特に人で埋め尽くされるような公共の場所を組織化し，方向性や全体像を与える。こうして，重層し統一性のないパブリックスペースと観客が一体になるような複数階におよぶヴォイドをつくり出す事と，この床面の操作は表裏一体となる。特に2階部分の，持ち上げられたホワイエスペースは，谷の南側へと繋がっており，街を堪能しながらくつろげるアンマン一の場所となり得るだろう。

〈機能構成〉
バス停およびGAM大通りからの人の流れが交わる屋外広場が，建物へのメイン・アプローチとなる。我々はここに車寄せも設けた。この主要な人の流れは，広場から入るメイン・エントランスから内部の大空間へと繋がる空間構成に反映されている。内部のヴォイドは，日中はパブリックに解放され，内部広場をつくり出す。ここは人が集う日陰の広場，情報交換が行われる広場，チケット売り場および公共展示スペースともなる。ここから小さなホワイエを介して，それぞれの劇場スペースへと入る。

高低差のある南側に設けられた2階のエントランスはVIP用であり，車寄せはドア際に設けられている。

アーティストおよびスタッフの出入口は建物の東側に配置された。ここにはグリーン・ルームやアーティスト用のカフェがあり，この施設における日々の創造性を精力的に支える全ての人々を迎え入れる。こちら側，つまりアーティスト室の周りや上，およびバックステージの裏側には，アーティストのための様々な部屋が設けられた。南側の端に沿ってスロープを設け，運搬用車両がここを通ってそれぞれの劇場へ地下からアクセスすることが出来る。これらの車両は人目に触れることなく敷地からプリンセス・バスマ通りに出られる。

この南側の軸に沿って，舞台裏のその他のスペースが並んで配置された。その上部においては，パブリックスペースのヴォイドが舞台裏の壁を侵食することで，観客の動線を確保し，南に開く大きな開口部をつくり出している。

この軸の西側のメインエントランス上部には学習施設を設けた。ここへは，メインエントランスから，エレベーターや階段で簡単にアクセス可能である。

〈車両のアクセス〉
地下駐車場の入口は敷地の北側に設けられた。この入口は配達用にも使用される。我々は，既存の邸宅，ホテルおよびアパート用の，独立した車寄せも提案した。

Elevation

Stone Towers

2008- Cairo, Egypt

View toward North Office Buildings

North Office Buildings: elevation

Overview

MASTERPLAN
RETAIL
NORTH OFFICE BUILDINGS
SOUTH OFFICE BUILDINGS
HOTEL

View toward South Office Buildings

North Office Buildings: section

107

North Office Buildings: level 0

South Office Buildings: level 5

North Office Building 4: elevation

South Office Building 4: west elevation

South Office Building 9: west elevation

North Office Building 4: longitudinal section through atrium

South Office Building: section

Site section

Stone Towers development is part of the wider Stone Park development which derives its name from an ancient petrified tree at the heart of the development. The New Cairo City site optimally positions the Stone Towers to offer state of the art office facilities to a rapidly expanding Cairo. The programmatic variety of the Stone Towers creates a rich mixed use environment for office tenants. The 525,000 sqm development also includes a five star business hotel with serviced apartments, retail with food and beverage facilities and a central feature landscape referred to as the "Delta".

The design mediates the two distinct edges of the site—the high-speed ring road to the north, and the Stone Park residential component to the south. With such a large scale project, care must be taken to balance a necessary requirement for repetitive elements while avoiding an uncompromising, repetitive line of static building masses. The architecture of the two bounding edge conditions pursues a rhythm of interlocking, yet individually differentiated building forms. Verbatim repetition is instead a series of similar, yet unique forms. This is complemented in the plan and section where the building edges visually interlock and merge with the landscape, creating a cohesive composition.

Egyptian stonework, both ancient and more recent displays a vast array of patterns and textures that, when illuminated by the intense sunlight of the region creates animated displays of light and shadow. The effect is powerful, direct and inspiring. The Pre-cast facades on the north and south elevations of each building edge emulate the effect using a vocabulary of alternating protrusions, recesses and voids. The richness observed in the intricate patterns carved into minarets and Egyptian Hieroglyphic patterns, with their variations in repetition and density have contributed to the abstract pattern specific to Zaha Hadid Architects' design for Stone Towers. Deep shadow lines reveal and accentuate the form of the north and south facades which reference the elegant curvatures seen in Egypt's ancient relief carvings.

North Edge Buildings

The North Edge buildings are taller and more vertical than the South Edge in response to the ring road at its north border. The 9 North Edge buildings form a gentle S-curve in plan along the edge of the slip road creating pockets for landscaping at the entrance drop-offs. The skewed orientation of these buildings creates two different effects when observed driving either west or east. From one direction the louvered East Facade is more prevalent. From the other, the curving, solid pre-cast facade dominates. Additionally, the building set-out creates a high degree of self shading for the more transparent east and west facades. Each building follows a similar set of rules, yet each building is entirely unique. Viewed from the north-south elevations, the buildings splay at the base or at the top in an alternating rhythm.

The point of curvature occurs at different heights animating the entire north-south elevations. When viewed obliquely, the gentle curvature appears as a series of ripples. A pattern of vertical slits runs through the North Edge pre-cast facade panels. The slits emphasize the verticality and allow apertures out from the north facade. Cut obliquely, the facade feels more or less solid depending on one's view angle.

The building wings are connected by an all glass reception space and external bridges that span across the building's courtyard. The full-height courtyard voids create a striking space and offers visitors a dramatic introduction to the building. Lift lobbies exit into a transparent reception area offering continuous views of the delta.

South Edge Buildings

The South Edge buildings are located adjacent to the residential development to the south. The South edge is lower in height and angles away from the drop-off edge. The buildings seem to emerge from the landscape as a series of ribbons forming a different condition facing the delta from the condition mentioned above facing the residential. To the delta side, a dramatic cantilever emerges becoming progressively more pronounced moving from the west to the east. When all South Edge buildings are viewed together, the entire edge has a strong visual coherence. The cantilevers project into the landscape offering fantastic views out for the office occupants. Additionally, the narrow office floor plate ensures generous amounts of daylight will reach all areas of the office interior.

Landscape and Retail

The landscape flows across the site connecting the bounding edges of the development to define the central, outdoor landscape, the "Delta". Water features, cafes, retail, shaded areas, and an exterior event space activate the landscape. These features form level changes and visually connect to the office buildings creating a pattern that weaves the entire composition together.

North Office Buildings (left) and South Office Buildings (right)

North Office Buildings: plaza

ストーン・タワー開発計画は広汎にわたるストーン・パーク開発計画の一環である。この名称は開発地区中心部の古代の木化石に由来している。ニュー・カイロ・シティのストーン・タワーの敷地は、急速な拡張を遂げつつあるカイロの文化的施設としての地位に最も相応しいものである。

オフィス入居者のための充実した複合的な環境は、ストーン・タワーの多様性に富んだプログラムの産物である。525,000平米の開発地区には、それ以外にも部屋ごとにサービスの行き届いた最高級のビジネスホテル、食料品や飲料品のための商業施設、中央部にはこの場所を象徴する「デルタ」という名のランドスケープがある。

この計画は、北に面した環状高速道と南に面したストーン・パークの居住区という二つの全く異なる性格の敷地境界を調停するためのものである。このような大規模プロジェクトにおいては、ともすれば静的な建築の集合体がつくり出す杓子定規な直線による反復的表現を回避するため、要求される反復的要素への配慮が求められなければならない。各々の敷地境界条件を構成するこれらの建築が追求するのは、重なり合いつつ常に差異化されてゆく、連続した建築的形態のリズムである。ここで言う反復性とは、自己相似的ながらも独立した形態の連続を意味している。これらの反復性は、平面と断面によく表されている。建築の外周は視覚的に重なり合いながら、自然へとひとつに溶け合って一貫性のある空間が生み出されている。

古代から近年に至るまで、エジプトの石加工品は膨大な種類の文様やテクスチュアを誇っている。これらの文様が、この土地の強烈な太陽光の下で躍動感溢れる光と影を生み出す様子は、力強く、真直ぐに心揺さぶるものである。各々の棟を縁取る南北立面のプレキャストコンクリートのファサードは、それぞれ異なった凸凹や空隙などのヴォキャブラリーを用いることで、そのような文様の視覚的効果を模倣している。ストーン・タワーの設計においては、カイロのミナレットに刻まれた複雑な文様や古代エジプトのヒエログリフの文様に見られる表現の豊かさが、パターンの反復や緻密な表現、レリーフの豊かさと相まって、建築家特有の抽象的パターンへと寄与している。南北のファサードのフォルムを引き立たせる深い開口部に落ちる影のラインは、古代エジプト彫刻に見られる優雅な曲線への言及である。

〈北オフィス棟〉
南棟と比べると北棟は比較的高く、垂直性が強調されている。これは北側の境界の環状高速道への応答である。平面計画では、9棟の北棟が高速道路のランプの縁に沿って緩やかなS字カーブを描き、エントランスの車寄せに植栽帯をつくっている。これらの建築の傾斜した軸線は、車に乗って東西から見た時に、それぞれ異なった視覚的効果を生み出している。一方から見ると東側ファサードのルーバ

ーが視線の大勢を占める。反対側ではプレキャストコンクリートのファサードの曲面が支配的である。さらに建築のセットバックが，一層透明性の高い東西のファサードに自身の影を深く落としている。それぞれの建築は相似的なルールに従うものの，各々について見てみるといずれも他とは異なっている。南北の立面を見ると，それぞれの建築の足元や頂上部は各々異なるリズムで傾斜している。

　各々異なった高さの湾曲点が，南北立面全体に対して躍動感を与えている。斜め方向から見ると，緩やかな曲面は波紋の連なりのようにも見える。垂直スリットパターンが北棟のプレキャストコンクリートのファサードパネルを走る。これらのスリットは垂直性を強調するとともに北面ファサードの開口部の役割を果たす。傾斜した切り込みのおかげで，見る向きにはよるものの，ファサードは堅牢な質感を湛えている。

　建築の左右のウイングは，全面ガラスのレセプション・スペースと建築の中庭に架け渡された外部ブリッジによって接続されている。建築の全高に及ぶ吹き抜けが印象的な中庭空間は，この建築の内部へと来館者を劇的に導く。エレベータ・ロビーから非常に透明感のあるレセプションエリアへと抜けると，そこからはデルタの風景が遠くまでひろがっている。

〈南棟〉
南棟は，敷地の南の住宅開発地域に隣接して位置し，北棟よりも低く，また車寄せからも離れて計画されている。あたかもランドスケープの一部が何本も帯状に立ち上がり，建築の一部となって，上述の住宅地域に面した側とは異なった状況をデルタに対して構成している。デルタ側では，西から東に移動するのにつれて，躍動的なキャンティレバーが次第にはっきりとした姿を現す。南棟全体を一度に見渡すと，全体の輪郭には強烈な視覚的一貫性を見て取ることができる。自然の中に突き出たキャンティレバーは，オフィス棟の入居者に外へと広がる魅惑的な眺望を提供する。さらにオフィスフロアは奥行きが狭いので，オフィス内部のあらゆる場所に太陽光が惜しみなくもたらされる。

ランドスケープとディテール
「デルタ」として定義された中央のランドスケープは，敷地の中を流れるように開発地域の南北の境界を結びつけている。水盤や，カフェ，店舗，木陰，屋外のイベントスペースがこの自然に彩りを与えている。これらの要素が階層の変化を構成し，視覚的に自然とオフィス棟とを結びつけ，全体をひとつの文様へと織り上げている。

South Office Buildings

Elevation details

CasArt

2009 Casablanca, Morocco

Elevations

Site context

An iconic architectural vision for a pretigious cultural facility in Casablanca, Zaha Hadid Architect's design interprets a very exposed and centrally located parcel at the heart of the city, not only as the new western face of Casablanca's main square, Place Mohammed V, but also as the connecting point between two major public spaces of the city. Its underlying urban strategy is to create an interface between the impressive green space of the Place de la Ligue Arabe—connecting the southern parts of the city to the centre via a large public green corridor—and the Place Mohammed V, the central assembly space in the heart of the town.

The project comprises of a hosting Opera House and a Theatre-cum-Black Box, with resturants and spacious event halls, which integrates itself with the main plaza upon which it sits. Together, they create a sculptural fluidity that expresses monumentality, permanence and grandeur.

The Plaza is envisaged as a tapestry for the multiple urban events and also as a seamless extension of the CasArts Complex. Here the static and formality of the former Place Mohammed V is replaced with a dynamic and inclusive design. Expressive flows and choreography of events and unfolding scenery of reflecting pools, palm groves and almond orchards welcomes you—elements of a Moroccan garden. The ground plane of the square is folded and mounded to create an intimate sense of enclosure which caters for a rich ensemble of functions where multiple audiences and activates can coexist, introducing an atmosphere of spontaneity and vibrancy.

The Plaza and CasArt are inconceivable without one another, with the landscape bridge acting as a stage for the grand procession into the arts centre. The organization of the building exploits the obvious synergy of the two performance spaces with its 'L'-shape configuration. Convergeing back of house activities into a tight and practical corner while fanning out in front a generous and lofty atrium space is created. Each volume is designed to cantilever, giving the impression of perching over to engage the plaza and the Parc. The continuous facade gently wraps each theatre, twisting and folding over, weaving itself into the vortex. Programmatically, this results in a series of interconnecting ramps and verandas where the grand procession of a theatre arrival unravels.

The many layers of visual interaction, all reflect the concept of creating an element of integrative openness, communication and public interaction to both enrich the urban fabric and the cultural landscape of Casablanca, creating an identification point not only for the local community but also contributing to and enhancing the greater image of the city at its very heart.

Lighting

この建築はカサブランカの由緒ある文化施設の象徴である。極めて人目に付きやすく，街の中心となるこの敷地を，街の中央広場，モハメドV広場の西の顔としてだけでなく，市内の主要な二つの公共空間を繋げる点として読み込んでいる。都市計画としては，その巨大な緑の通路で街の南側と中心部を繋げ，強い存在感を放つアラブ連邦広場の緑地帯と，街の核となる中央広場であるモハメドV広場を連結させることを試みた。

このプロジェクトは，オペラハウス，劇場兼ブラックボックスシアター，レストラン，および広いイベントホールによって構成されており，広場と一体化している。これらの空間は，モニュメント的な永遠性や壮大さを，その流動する造形によってつくり出している。

広場は都市で起こる様々なイベントを映し出すタペストリーとして，またCasArtsの施設のシームレスな延長としてもデザインされた。以前のモハメドV広場の動きのない形式的な空間は，人々の感情があふれ出すような，踊りや様々な催し，池やヤシの木，アーモンド畑が織りなす風景で訪れる人々を迎える。

Site plan

それらはモロッコの庭に備わっているものだ。広場の地面は折れ曲がって膨らんでおり，包み込むような密接な空間をつくり出す。そこでは，それぞれの機能が濃密に交わり合い，多くの観客やアクティビティが共存し，即興的で活力にみなぎる雰囲気を生み出している。

広場とCasArtは二つで一つの存在であり，

ランドスケープの一部である橋は，この芸術センターへと導く壮大なステージとして機能している。建物の配置はL字型で二つのパフォーマンススペースの機能をそのまま反映する形となっている。舞台裏の空間はコンパクトで使い勝手の良いコーナーにまとめ，前方では広がりを持ちゆったりとした広さのアトリウムを形成している。それぞれのヴォリュームはキャンティレバー状にデザインされており，広場と公園を一体化させ迫ってくるような印象を与えている。連続するファサードはそれぞれの劇場を包み込み，捩れながら折れ曲がり，うねりのある渦を形成している。機能的には，結果として，いくつかのスロープやバルコニーをつくり出し，劇場入口での大行列が分散される。

視覚的に各階は繋がれており，構成要素としての開放性，コミュニケーション，および公共性といったコンセプトを体現しており，カサブランカの都市機能や文化的ランドスケープを豊かにしている。ここは地元のコミュニティを象徴する場所としてのみならず，街の中心においてさらなる大きな都市像を形成し，また強調もしている。

Night view: plaza with lighting

Level 0 (1.0 m): grand foyer

Level 1 (6.0 m): auditorium

Level -1 (0.3/0.6 m): car park

Longitudinal sections

Level 3 (16.0 m): auditorium, event hall, restaurant

Level 5 (26.0 m): arministration, bureaux

Level 2 (11.0 m): auditorium

Level 4 (21.0 m): event spaces, restaurant

Cross sections

117

Approach

Ramp

Ramp

Main auditorium

Theater

Sunrise Tower

2009 Kuala Lumpur, Malaysia

Zaha Hadid Architects' design for Sunrise Tower engages with the city in multiple ways. By exploring potential synergies at different levels and anchoring itself to the existing urban fabric, it creates a platform of services that engage with neighbouring developments, sustaining critical mass and a sense of community. The scheme merges all programmes into one building, distancing itself from the traditional tower and podium typology. Through a detailed landscape strategy the design interweaves tower and ground, extending and connecting the different parts of the site, integrating the new pedestrian routes and internal road system, structuring the fabric of the new development.

The design houses 5 different programmatic components: residential, hotel, offices, retail and parking. Connectivity between these parts becomes central to the project in order to produce an articulated design that encompasses both the scale and the different qualities of each of the parts, fusing them into a coherent scheme. The program is stratified, stacking one function over the other, or carrying them in parallel when the tower branches. Programmatic synergies are created by blending certain programmatic aspects that are common to create powerful spaces that not only differentiate between programs but also enable a system that separates public from private, yet integrating the necessary security features to organize a seamless transition between environments.

The design concept creates spaces that blur the difference between building and landscape, intensifying the fluidity between interior and exterior. The tower body is developed through a performative outer skin that merges programmatic, structural and building envelope requirements. A spatial grid is generated through parametric component design, enabling the local adaptation of each component to accommodate for different requirements within a pool of repeated elements. Components variation is choreographed through the floor grid with a rhythm that is defined by topology, orientation, programme and structural load, generating a customized gradient that mutates from strong diagonals at the base to gentle verticals at the top.

The programmatic parameter also develops a grid of occupation, a modular system for hotel rooms and residential apartments. Because this grid is integral to the buildings

Longitudinal section *Cross section*

topology and structure, tube-in-tube system, the partitioning system becomes interchangeable, constructing a flexible landscape to be tailored to the client's requirements, capable of assimilating changes in short, medium and long terms. The created pattern is supported through the structural frame elements, carrying the building's facade and generating interesting elegant views through the tower. Its design concept integrates natural light, shading, program, access and views, making the component the key operator of the transition between interior and exterior spaces.

The building is designed through a series of independent flows that map the tower and organize different routes for different programmes. Along these routes the lobby and shared facilities floors work as communication hubs, like intersections that enable flexible itineraries and changes between uses. Similarly to the skin, the circulation materializes as a multi dimensional spatial grid, inclusive of the program, treating interior and exterior in a seamless way, thus maximizing the clarity of the scheme and the perception of the different levels. The design of a clear navigation system for lobbies, atria and common areas, enables visual communication as well as access through the cores, ensuring fully accessible environment for all users.

The building's complex programme is distributed through 66 floors in total, 4 bellow ground and 62 above ground, with an absolute height of 280 m. The ground lobby is the primary hub of the tower, defining 4 different dedicated lobbies for residential, hotel, offices and general public.

サンライズ・タワーの計画はさまざまな手法で都市と結びついている。多角的な側面から潜在的相乗効果を探究し、建築をこの場所の状況へと深く結びつける。この建築は周辺の地域開発への関与、クリティカル・マスの維持、地域コミュニティへの所属といった取り組みへの礎である。この計画では、プログラムはすべて高層部と基壇部といった伝統的タイポロジーからは遠く離れて、ひとつの建築として同化している。敷地内のさまざまな場を拡張・連結し、新しい歩道と内部の交通システムを統合し、新しい開発計画の骨格を構築する。緻密なランドスケープ戦略を通して、計画では高層棟と地表面が一体的に織り上げられている。

この計画のプログラムは五つの異なった部門から構成されている。すなわち集合住宅、ホテル、オフィス、店舗、および駐車場である。そのため、これらの部門同士の関係性を構築することが建築計画の主要な課題となった。建築を分節化し、スケールや機能の異なる各々の部門を包含し、一貫した全体計画へと融合させる。プログラムを階層化し、それぞれの機能を積み重ね、タワーの分岐する箇所では機能が平行的に構成される。プログラムのさまざまな側面を融合することで、プログラムには相乗効果がもたらされる。力強い空間にはそのような相乗効果が備わっているものである。このシステムが可能にするのは、プログラムの差異を峻別し、パブリックとプライベートを分け隔てるとともに、環境から環境へと滑らかに移動するのに必要な、安全面における統合である。

ここでの設計理念は、建築と自然の差異を曖昧なものとすることで内部空間と外部空間の関係性を流動的なものとすることであった。建築の形はプログラムや構造、斜線制限を組み合わせて遂行的に外皮を検討したことによるものである。空間グリッドを生成するのはパラメトリック・コンポーネント・デザインである。反復的要素の集合体の個別の要求に応えるために、各々のコンポーネントをその場所に相応しい形へと適応させている。コンポーネントのバリエーションはトポロジー、方位、プログラム、構造負荷によって決められたリズムで、フロア・グリッドに沿って振り付けられている。そこから生み出されるのは、明瞭に傾斜した基壇部分から繊細で垂直的な頂部へと変化する外皮のコンポーネントである。

ホテルや集合住宅のモジュール・システムなどの専有区画のグリッドもまた、パラメタのプログラム操作によるものである。このグリッドは建築のトポロジーや構造、複層チューブ・システムを構成する一部である。パーティション・システムは交換可能なものとして、柔軟性に富んだ屋内のランドスケープは短期、中期、長期にわたってクライアントの要求に同化することができる。生成されたパターンは構造フレームによって支持されている。フレームが支える建築ファサードから

Ground floor

Study: elevations

Study: volume

PLAN 21_HOTEL ROOMS / TYPICAL OFFICES

PLAN 62_TYPICAL RESIDENTIAL

PLAN 19_HOTEL ROOMS / TYPICAL OFFICES

PLAN 46_TYPICAL RESIDENTIAL

PLAN 12_HOTEL ROOMS / TYPICAL OFFICES

PLAN 33_TYPICAL RESIDENTIAL

PLAN 09_RETAIL

PLAN 29_RESIDENTIAL SKY LOBBY_SPA / HEALTH CLUB

Upward view

Initial components *Resulting pattern* △▷ *Programme strategy*

は，気品ある風景を楽しむことができる。このデザイン・コンセプトは自然光，日影，プログラム，アクセス，眺望を統合したものである。コンポーネントは内部空間と外部空間の関係性を操作する主要オペレータとして機能している。

　この建築は独立した動線フローの集合である。タワーを構成する各フローは，各々のプログラムに個別の動線ルートを提供している。これらのルートに従い，ロビー階と共用施設階はコミュニケーション・ハブとして機能する。これらは自由に行き来することのできる，さまざまな用途に使える交差点のようなものである。表皮と同様に，循環動線は多元的な空間グリッドとして形象化されている。プログラムを包括し，内部空間と外部空間を滑らかに結びつけ，その結果，全体計画の明晰性を最大化することで異なる階層に対する認識が促される。ロビーやアトリウム，共用部の明瞭なナビゲーション・システムの設計は視覚コミュニケーションやコアからのアクセスを可能にすることで，全ての利用者に完全に利用可能な環境を提供している。

　この建築の複合プログラムは地下4階，地上62階，合計で66階にわたる。建築高さは地上280mに及ぶ。地上ロビーはこのタワーの中心ハブとして，集合住宅，ホテル，オフィス，および一般的な公共空間のために四つの専用ロビーの役割を果たす。

Gui River Creative Zone

2009 Beijing, China

Southwestern view of site looking towards northeast

Urban strategy: overall site plan

Programmatic distribution

Street section through private street *Street section through public street*

Site strategy

Zaha Hadid Architects' design takes the basic idea of the campus as a singular and privileged environment, and gives it a fresher and more intensive atmosphere. We have tightened the associations, strengthened the connectivity and applied directionality, moving with the lines of growth and the trajectory of the Gui River. Like the campus, the design interrupts the standard suburban grid and expresses the activity of a special working community, but highlights the immense degree to which engineering and building technologies have moved forward, allowing us to envision new formal arrangements and productive landscapes.

The overall plan recognizes the force of the river and the parallel transport infrastructure, and preserves their specific values while creating a gracefully undulating space of integration and activity moving between them. This central space works like that of the classic shopping mall, distributing and connecting the anchor elements of a new community of endeavour. These elements are formed by the building clusters associated with the primary programmatic drivers of the plan—the design school, the exhibition centre, and the hotel—and their spatial interaction generates the logic of an open and generous parkway of activity stretching among them. The overall logic favours synergy while retaining the possibility of phasing and accommodating cycles of investment and stakeholder development.

The architectural concept for the development is a series of relatively low rise modular dwellings; each with a free-form roof profile creating a dramatic roofscape both at masterplan scale and at a more intimate building scale.

The hotel, exhibition centre, and design school each offer programmatic affinities which suggest subtly differentiated spatial ecologies. The design identifies the key parameters of an innovative spatial language that enables the plan to progressively define the key building clusters. Repeating and self-similar elements of a manipulated ground, podium, envelope, and recessed facade allow an understanding of the principles of cell formation for a future urban pattern. This planning approach emphasizes the new potentials of computational technology to avoid the simply generic. At the heart of the overall structure of the plan, the clusters are composed of simple, expressive pavilions, organized to accentuate the strengths of the surrounding landscape and new industrial associations.

FORMING CLUSTERS
塑造建筑集群

Overall perspective of Hotel Cluster

我々はこのキャンパスの基本構想を特殊かつ恵まれた環境として捉え，そこに新鮮で活気に溢れた雰囲気を与えようとした。媯河の流れを意識して，計画全体につながりと方向性を強くもたせている。この敷地と同様，郊外によくみられる標準グリッドから脱した特殊なデザインによって，コミュニティによるアクティビティの特殊性を表現している。同時に，エンジニアリングと建設技術の大規模な発展を強調することで，新たな配置の形式や美しい風景を生み出そうとしている。

全体のプランは河に平行に走る交通インフラの流れを読み取り，それ自体がもつ力を生かしつつ，統一感のある，多様なアクティビティを許容する優雅に波打つような空間をつくりだす。中央の空間には，ガレリアのように，新たなコミュニティを構成する重要なエレメントを配置して，それらを繋ぎ合わせている。それらのエレメントは，全体計画の主要プログラムにおける要求と密接に関連した建物の集合によって構成される。デザイン・スクール，展示場，ホテルは，その中に展開する広々とした開放的なパークウェイを生み出す。投資開発のサイクルをうまく取り入れながら，全体計画との相乗効果を生むことを目指した。

比較的高さを抑えたモジュールによる住宅を連続させることがこの開発での建築的コンセプトである。これらの住宅の屋根はそれぞれ自由な断面形状をしており，マスタープラン全体のスケール，およびそこに住まう人々のスケール，どちらから見ても素晴らしい屋根の風景をつくる。

ホテル，展示場，そしてデザイン・スクールはプログラム上で類似性を持つ。革新的な空間言語のカギとなるパラメータを決定することにより，主要な建物の集合体が漸時決定される。人工的に操作した土地や基壇などの自己反復的なエレメントやシンプルなファサードは，未来の都市像の細胞構造の法則の理解に基づく。我々は，単なるジェネリックな開発となることを回避するため，コンピュータ技術の潜在的な可能性を探った。この計画の根幹となる構造のなかで，建物の集合はシンプルかつ表情に富んだパヴィリオンで構成され，周辺のランドスケープが持つ可能性と産業との関係性をより深めるように計画した。

HOTEL CLUSTER
酒店建筑集群

EDUCATION CLUSTER
教育培训建筑集群

PRIVATE AREA — SUITE ROOMS 高级豪华套房
LEISURE HEALTH CLUB 健康及休闲设施
PUBLIC AREA — LOBBY BAR AND RESTAURANT 大厅及酒吧餐厅区
PUBLIC AREA — CONFERENCE 会议及宴会区

PRIVATE AREA — STUDENT DESIGN STUDIOS CLASS ROOMS 设计工作间及教室区
PUBLIC AREA — LECTURE 报告厅区

TYPICAL CLUSTER DIAGRAMS 典型集群建筑示意图
A. LEVELS 楼层
B. CIRCULATION 空间动线
C. FACADE LINE 立面边线
D. ROOF/FACADE/LANDSCAPE 屋顶/立面/景观
E. EDGE CONDITIONS 边界
F. VOIDS WITHIN CLUSTERS 集群中的虚空

KEY SPACES
1. HOTEL SUITES 豪华套房
2. MAIN LOBBY 大厅及酒吧餐厅区
3. LEISURE HEALTH CLUB 健康及休闲设施
4. HOTEL ROOMS 标准套房
5. CONFERENCE AREA 会议及宴会区

Typical Hotel Layout 1:1000 /Ground Level
酒店集群 典型一层平面图 1:1000

HOTEL CLUSTER DIAGRAMS 酒店集群 分析示意图
A. CIRCULATION 动线
B. HEIGHT LEVELS 建筑高度层
C. CELLULAR ORGANIZATION 空间细胞
D. VOLUME/VOID 虚/实空间

Typical Education Layout 1:1000 /Ground Level
教育培训集群 典型一层平面图 1:1000

Typical Education Layout 1:1000 /Upper
教育培训集群 典型上层平面图 1:1000

KEY SPACES
1. CLASS ROOM
2. DESIGN STUDIO
3. LECTURE HALLS AND EXHIBITION
4. LIBRARY
5. ADMINISTRATION AND OFFICES
6. SUPPORTING SERVICES

EXHIBITION AND RETAIL CLUSTER
会展及商业建筑集群

Rhythmical Movement/Elevation of Exhibition Cluster
会展商业集群建筑立面律动示意图

Typical Exhibition Layout 1:1000 /Ground Level
会展商业集群 典型一层平面图 1:1000

Prototypical Exhibition Cell
会展单元原型

EDUCATION CLUSTER DIAGRAMS 教育培训集群分析示意图
A. CIRCULATION
B. HEIGHT LEVELS
C. CELLULAR ORGANIZATION
D. VOLUME/VOID

EXHIBITION & RETAIL CLUSTER DIAGRAMS 会展商业集群分析示意图
A. CIRCULATION
B. HEIGHT LEVELS
C. CELLULAR ORGANIZATION
D. VOLUME/VOID

KEY SPACES 空间索引
1. EXHIBITION 展厅
2. RETAIL 商业区
3. CAFE/RESTAURANT 餐饮
4. SERVICES 设施

TYPICAL DIAGRAMS FOR EXHIBITION CELL 会展单元原型示意图
A. PRIVATE SECTION
 PUBLIC SECTION (SHADED AREA)
B. CIRCULATION

PROTOTYPE
建筑原型

Northeast view

Southwest view

Longitudinal section

Cell type

Diagram: prototypical components explosion

130

A. study: height
B. study: vertical structure
C. study: openings
D. study: leaning

Prototypical structure evolution

Interior: view from mezzanine

Ground floor

131

The Circle at Zurich Airport

2009 Kloten, Switzerland

Site plan

Ground floor

133

Level 2

Level 1

The Circle at Zurich Airport was a design competition for an amenities and business ecology extension to Zurich International Airport in Kloten, Switzerland. Occupying a semi-circular site between the airport's main buildings and a wooded green hill, the building will contain offices, brand space, medical tourism clinics, classrooms, lecture halls, restaurants, cafes, hotels, spa, gym and a large multi-purpose hall.

Architectural Concept
The fluid shapes of the building respond to two conditions. There is the compact and continuous adjacency to the airport on one side and a convex and eroded condition on the other side in order to maximise the perimeter, to embrace nature and to take maximum advantage of views.

The building's "interior urbanism" encourages interaction amongst different programmatic modules and sharing of facilities open to the public, whilst maintaining a practical vertical stacking for each module, aimed at rationalizing services and circulation.

Critical importance has been assigned to clarity of access and to the relation of entry to both horizontal and vertical circulation within the complex. These will be related to three major voids or "canyons" cutting through the building section and merging in an open plan top floor.

These "canyons" cover three critically important functions: to indicate major points of entry into the complex, to reinforce the major circulation routes (both horizontal and vertical) and to create a variety of depths of floor plate appropriate to the mix of uses to be accommodated.

The top (8th) level performs as open plan "streetscape"—a promenade dotted with retail (brand space and showrooms), cafe and restaurants. Using a "shopping mall" paradigm, Spa and Sky Bar belonging to the 5-star hotel on the north end and exhibition plus restaurant on the south end, act as anchor attractors propagating visitors' flow throughout the building's length.

Because of its mixed-use nature along the lines of a shopping mall, we propose that the complex should be managed and operated as such, i.e. brand orientated, performance related, feedback rich, with flexible rent and leasing structures to encourage the cohabitation of complementary uses.

チューリッヒ空港の「ザ・サークル」は，スイスのクローテンにあるチューリッヒ国際空港の文化および商業施設の増築コンペ案である。建物は，空港のメインターミナルと樹木で生い茂った丘に挟まれた半円形の敷地に建ち，オフィス，ブランドショップ，観光客用のクリニック，レクチャーホール，レストラン，カフェ，ホテル，スパ，ジム，そして大きな多目的ホールによって構成されている。

〈コンセプト〉
建物の流れるような形態は二つの条件に対し配慮されている。一方は空港ビルにコンパクトに，かつ連続して近接しており，また一方では凸状に侵食された部分を持つ。そうすることで建物の周縁を出来るだけ引き伸ばし，自然を抱擁しそこからの眺望を最大限確保している。

建物の「インテリアにおける都市計画」は，様々な機能の構成部分の交わりや，公共に開かれた施設の共有を促進し，かつそれぞれの構成部分を効果的に垂直方向に積み上げ，サービスや動線の合理化を目論んでいる。

アプローチの明確性，および施設内におけるエントランスから水平・垂直方向への動線の関係性が極めて重要な課題であった。これらは三つのヴォイドとして形になった。それらは「谷」と呼ばれ建物断面を貫通し，屋根部分へと同化している。

これらの「谷」は三つの重要な機能を担っている――施設内への主要なエントランスを視覚化すること，主要な（水平および垂直方向の）動線を強調すること，床面に多様な奥行きを与え，様々な用途を可能にすること。

最上階（9F）は外に開かれ，「町並み」をつくり出しており，遊歩道沿いには商業施設（ブランドショップやショールーム），カフェやレストランが点在している。スパや五つ星ホテルに付随するスカイバーは北側の端に配置し，展示スペースやレストランは南側に配置されており，「ショッピングモール」の定石に従っている。人を呼び込む起点をつくることで，来客者を建物内に分散させることが可能となる。

ショッピングモールのような多目的な性質を持つため，我々はこの施設の運営方法を次のように提案した――ブランドを重視し，効率的に経営面での十分なフィードバックを保つ。そしてフレキシブルな家賃システムにする。これらにより，相互補完的な共生が促される。

Level 8

Level 3

East elevation

West elevation

Sections

Circulation of visitors

Diagram

137

△▽ *Atrium*

Sectional detail: hotel (left) and office (right)

Galaxy Soho

2009-12 Beijing, China

View from northwest corner

The Galaxy Soho project in central Beijing for Soho China is a 330,000 m² office, retail and entertainment complex that will become an integral part of the living city, inspired by the grand scale of Beijing. Its architecture is a composition of five continuous, flowing volumes that are set apart, fused or linked by stretched bridges. These volumes adapt to each other in all directions, generating a panoramic architecture without corners or abrupt transitions that break the fluidity of its formal composition.

The great interior courts of the project are a reflection of traditional Chinese architecture where courtyards create an internal world of continuous open spaces. Here, the architecture is no longer composed of rigid blocks, but instead comprised of volumes which coalesce to create a world of continuous mutual adaptation and fluid movement between each building. Shifting plateaus within the design impact upon each other to generate a deep sense of immersion and envelopment. As users enter deeper into the building, they discover intimate spaces that follow the same coherent formal logic of continuous curvelinearity.

The lower three levels of Galaxy Soho house public facilities for retail and entertainment. The levels immediately above provide work spaces for clusters of innovative businesses. The top of the building is dedicated to bars, restaurants and cafes that offer views along one of the greatest avenues of the city. These different functions are interconnected through intimate interiors that are always linked with the city, helping to establish Galaxy Soho as a major urban landmark for Beijing.

北京中心街のSoHoチャイナにおけるギャラクシーSoHoプロジェクトは，総面積330,000平米のオフィス，および商業エンターテイメント施設である。北京の巨大なスケールにアイディアを得たこのプロジェクトは，活気づく都市と密接に関わっている。建築の構成としては，ひとつながりに流れるような五つのヴォリュームが，独立し，一体となり，また引き伸ばされたような橋によって連結されている。これらのヴォリュームは相互にあらゆる方向に向っており，形態の流れを壊すような角や唐突な変化もなく，全体を楽しめる建築となっている。

このプロジェクトにおける壮大な内部のコートヤードは，連続した外部スペースが展開される中庭を内包する中国伝統建築を参照している。この建築はただの箱で構成されておらず，ヴォリュームが交じり合って絶え間ない対話を引き起こし，それぞれの建物間に流動的な動きをもたらしている。幾つかの平面をずらすことで，浸入され包み込まれるような，深みのある感覚を引き起こす。使い手が建物深く入り込むと，同じ流動性を保ったさらに密接な空間を発見する。

ギャラクシーSoHoの地上3階は公共性を持つ商業エンターテイメント施設である。その上部の階は革新的なビジネスが集まるオフィススペースとなる。建物の最上階にはバー，レストラン，そしてカフェを配置し，そこからは街随一の大通りを望むことが出来る。このような様々な機能は内部で密接に繋げられており，街とも常に繋がっており，ギャラクシーSoHoが北京の主要なランドマークとなるように意図されている。

Northeast plaza

Aerial view from northeast

East elevation

141

Site plan

Lower level

North elevation

East elevation

142

Upper level 1

Upper level 2

Cross section

Longitudinal section

143

Detail sections

Cairo Expo City

2009- Cairo, Egypt

View from east: Exhibition Centre (large volume) and Conference Centre (small volume)

Exhibition Centre (left) and Conference Cenre (right)

View from north: Exhibition Centre on right

Exhibition Centre

Roof

Level +9.0

Ground floor: Conference Centre (left) and Exhibition Centre (right)

Level +5.5

North elevation

East elevation

South elevation

West elevation

Sections

149

Exhibition Centre

Conference Centre

Auditorium *Foyer*

Conference Centre

South elevation

North elevation

East elevation

West elevation

Zaha Hadid Architects' proposal for Cairo Expo City delivers an iconic architectural vision for a unique facility for Cairo, a city for Exhibitions and Conference between downtown Cairo and the airport. The project comprises a major international exhibition and conference centre with business hotel. In addition to the above two office towers and a shopping mall are proposed, creating a rich ensemble of diverse functions which caters for multiple audiences and activates the site across different times and days of the week.

The urban strategy of the Cairo Expo pursues the idea of creating a homogeneous urban cluster mass that adapts to the site boundaries. Analysing the brief, we have understood the scale of the project in terms of the connectivity points and the program distribution. We have proposed a carving of the urban mass into smaller clusters that can work as individual buildings and have their own massing features, however relating to part of the overall design.

This concept is driven and inspired by the Nile delta that has pumped the life in to Egypt. On Cairo Expo City site the carving and sculpturing process starts from this artery, running through the site, connecting the north to south. Secondary streams formed by crowd movements toward the site converge to the centre. The designed movement of people within these streams also start to form and adjust the building entrances on the site. The horizontal expansion of the Exhibition Centre is balanced by introducing a three vertical elements, in the form of towers; the Hotel, and two offices towers, at the northern part of the site, overlooking Salah Salem Street.

The fluidity of the landscaped spaces feed the undulating vortex forms of the Cairo Expo City buildings. In particular, vortex lines and fields of the landscape merge into the patterned skin of the individual buildings, nature resonates throughout this site.

カイロ・エキスポ・シティで提案するのは，カイロ商業地区と空港の中間地点に建つ展示場・会議場都市として，カイロで随一となる施設に相応しい建築に，象徴的ヴィジョンを付与することである。この計画はビジネスホテルを備えた大規模な国際展示会議センターによって構成される。また，併せて提案される2棟のオフィス・タワーとショッピングモールの機能豊かなアンサンブルが，さまざまな来場者の要求を満たし，毎日昼夜を問わず，この場所を常に活気あるものにする。

カイロ・エキスポ・シティの都市コンセプトは，敷地境界線に沿って均質的な都市クラスターのマッスを創造するという構想を追求することにあった。設計概要を分析して分かったことは，動線の結節点とプログラムの分配計画という観点からこの計画のスケールを理解するということであった。我々が提案したのは都市スケールのマッスをより小規模のクラスターに分割し，各々完結したマッスを特徴とする個別の建築として機能させる一方で，これらを全体計画の一部に関連付けることであった。

このコンセプトは，エジプトに生命をもたらしてきたナイル・デルタから強くインスピレーションを受けたものである。カイロ・エキスポ・シティではこの大動脈を手がかりに，彫刻的プロセスが敷地を縦断して南北をつないでいる。敷地へと向かう群衆から派生的に生み出される流れるような空間は，全て中央へと収束する。流れに沿って人々が動く。このことが，敷地に沿って建築のエントランスの位置を調整し，あるいは構成する手がかりとなった。高層建築として3棟の垂直要素を導入することで，水平方向に展開する展示センターとの調和が図られている。すなわち敷地の北側でサラーフ・サーレム・ストリートを見晴らすホテルと二つのオフィス・タワーである。

流れるようなランドスケープ空間はカイロ・エキスポ・シティの建築の起伏に富んだ渦巻く形態をより一層引き立てている。渦のようなランドスケープの線と面とが混じり合い，各々の建築の表皮の模様と溶け合うと，自然が，この敷地のあらゆる場所で共鳴する。

Ground level

Longitudinal section

Section AA'

Section BB'

Wangjing Soho

2009- Beijing, China

Site plan

Upper level 1

Upper level 3

Upper level 2

Level 0

The Wangjing Soho building complex is a beacon along the way to Beijing's modern gateway, the Capital Airport, and the journey of transition to and from the city. The project acts as a welcoming post to the city and a gesture of farewell when departing Beijing. The buildings achieve this by reading differently when transitioning in either direction, leaving distinctly different impressions on those who pass by. Like Chinese Fans, the two volumes appear to move around each other in an intricate dance, each embracing the other from a continuously changing angle. This interplay creates a vibrant architectural complex that is enhanced by an equally dynamic external skin, which continuously varies in density creating a shimmering, exciting presence.

The building is articulated into a major and minor volume, each embracing the other as two distinct forms that form a single design. Each volume houses the office space, and the two are connected by a retail podium that unites the two buildings and creates a transition to the surrounding, fluid landscape design. This articulation helps implement the project in two construction phases, and helps differentiate and loosen the building mass within the given site, boundary, and solar envelope constraints.

Each building has a slender, curved form in both plan and overall elevation. These curving forms accentuate the embracing gesture of each building, but also help provide each office area with distinctly different views of Beijing. The building masses are overlaid with a series of oblong, curved atria or cutaways in the facade which provide localised opportunities within the building for small gathering spaces or cafes for the occupants.

The buildings are planned with a standard 8.4 m office grid, allowing for flexible usage and clearly defined apportionment of office layouts. The long, slender floors are efficiently catered for in terms of vertical transportation and services by a series of sequentially placed compact cores.

The Retail Atrium provides three levels of retail, shopping and restaurants for the building occupants and people living and working in the area. The retail space is articulated as a connective atrium between the Phase 1 and Phase 2 buildings, and has at its core a "pedestrian street" that is carved between the buildings at the B1 level, providing a generous, triple-height atrium crisscrossed with bridges and escalator that makes for an exciting shopping experience.

The entire Wangjing Soho complex sits on top of a raft foundation system that houses parking on three basement floors, catering to both office occupants and retail shoppers who visit the Retail Atrium.

North elevation

Section

East elevation

　望京Sohoコンプレックスは，今日では北京の表玄関となった北京首都国際空港へ向かう途上の，あるいはこの町にやってきたことを告げる灯台の役割を果たす。この計画はこの町に到着した人々を迎える道標であり，北京からの出発を見送るひとつの身振りでもある。この建築は方向によって見え方が変化する。このことが，通り過ぎる人々に完全に異なる印象を与えている。中国の扇子のような二つのヴォリュームは難しいステップを踏みながらお互いの周囲を踊る舞踏家のようである。お互いが違う角度から，常に相手を包み込もうとしている。この相互作用が生きた複合建築をつくり出す。そのような動きをより一層強調するのは，濃淡を常に変化させながら光揺らめく存在が魅惑的な，躍動的な姿の外皮である。

　この建築は大小のヴォリュームに分節化されている。お互いが他方を包み込むように，二つの異なる形態がひとつの形をつくりだしている。オフィス空間を収容する各々のヴォリュームは店舗のある基壇部で結ばれている。この基壇部は二つの建築を結びつけ，周囲の流れるようなランドスケープ・デザインへの空間的変遷を生み出している。このような分節化は建築計画を二段階に分けるとともに，敷地の形状や境界線，日影制限などの規制のなかで建築のマッスを分化し縮小させる手がかりとなった。

　各々の棟は平面と立面全体の双方において，ほっそりとして曲線的な形態をしている。これらの曲線的な形態はお互いを包み込むような身振りを強調しながら，それぞれのオフィスから北京の全く異なる景色を臨むことができるようになっている。建築のマッスは細長く伸びた曲線的なアトリウムや大きく前面をカットされたファサードに覆われているため，これらの空間では小規模なミーティングスペースや入居者のためのカフェといった具合に部分的に建築を利用することができる。

　この建築は標準的な8.4mのオフィス・グリッドで計画されているため，柔軟な利用と，オフィス・レイアウトの明快な配置計画が可能である。垂直動線やサービス動線という点では，連続的に配置された小規模なコア・スペースによって，細長く伸びるフロアにサービスが効率的に提供されている。

　リテール・アトリウムにはこの地域に住み，働く人々や入居者のための物販店やレストランなどの店舗が三層にわたって入っている。店舗区画は第一期建築と第二期建築をつなぐアトリウムへと分節化され，中央部には「ペデストリアン・ストリート」が二つの棟の間，地下1階に置かれる。三層のゆったりとしたアトリウムには，ショッピングを十分楽しめるようにブリッジやエスカレータが十文字に架け渡されている。

　望京Sohoコンプレックス全体は，ラフト基礎構法の上に建てられている。基礎部分には地下三層にわたって，オフィス入居者とリテール・アトリウムに訪れる買い物客の双方のための駐車場が収容されている。

King Abdullah Petroleum Studies and Research Centre

2009- Riyadh, Saudi Arabia

Site plan

The design approach for the King Abdullah Petroleum Studies and Research Centre has solid technical and environmental considerations at its heart, but the architecture endeavours to move beyond the individual constraints to create a living, organic form that transcends the simple technical strategies and has a strong expression in and of itself.

The research centre is by its nature a forward-looking institution, and the architecture also looks to the future with a formal language that can continually expand or transform without compromising the visual character of the complex.

A cellular structure of crystalline forms emerges from the desert landscape, shifting and evolving to best respond to environmental conditions and internal functional constraints. Consistent organizational, spatial, and structural strategies drive all elements of the plan. The approach is adaptive. Each unit is differentiated in size and organization to best suit its use. Individual buildings are divided into their component functions, and the forms can readily respond to changes in requirements or arrangements.

The architecture is protective from the outside and porous on the inside. While giving a strong, hard shell to the outside, the architecture opens up within as a series of sheltered courtyards that bring softly controlled daylight down into all of the spaces. A system of layering and buffered zones creates soft transitions from the hot and glaring exterior to cool and filtered interiors.

First floor

Ground floor

Ceiling

Approach

Place of Icon

161

アブドラ王石油調査研究センターのデザインにおいては，技術面や環境面の課題を十全に考慮することが重要視された。建築に関しては，個々の制約を超え，単なる技術的戦略を超え，かつそれ自体を強く表現している有機的，生命的形態を生み出すことを目指した。

研究所というものはその性質上，先進指向の機関である。その建築も同様に，複合体の視覚的特徴に矛盾することなく断続的に拡大し，その姿を変えてゆくことができるような形式言語を備えた，未来志向の建築が求められる。

細胞状構造をもった結晶状の形態が砂漠の風景の中に現れる。それは外部環境と内部の機能的要求に応答し，最適な形態へと姿を変え，進化する。一貫した組織的，空間的，構造的戦略がプランのあらゆる要素を決定している。我々は，適応性という観点からアプローチした。それぞれのユニットは，機能に応じてサイズやプランが異なる。個々の建物はそれを構成している機能に分割され，形態は使用上の要求や配置の変化に容易に適応することができる。

この建築は，外部に対しては閉鎖的でありながら，内側では多孔的，開放的である。外部に対しては強固なシェルを与えているのに対し，穏やかにコントロールされた自然光を内部空間にとりいれる中庭を連続して設けることで，開放的な表情をもたせている。バッファー・ゾーンのシステムにより，太陽のぎらつく灼熱の外部から涼しく保たれた内部空間への緩やかな環境の変化をつくりだした。

Circulation diagram (ground level)

Site elevation

Site sections

Concept images

Worship room

Courtyard

Atrium

Multipurpose room

163

New Dance and Music Centre, The Hague

2010- The Hague, The Netherlands

Site plan

Level 07 (+28.00)

Level 10 (+42.00)

Level 01 (+6.50)

Level 04 (+16.00)

Level 05 (+19.40)

West elevation

East elevation

South elevation

North elevation

Section A-A'

Section B-B'

165

Diagram: circulation

PROJECT CONFIGURATION DIAGRAM

MEDIA FACADE - LOUVERS

4 MAIN HALLS - AUDITORIUMS
1. THEATER_500
2. THEATER_350
3. THEATER_1000
4. THEATER_1500

INTERIOR FLOOR SLABS

PUBLIC AREA
BENCHES + GREEN AREAS + WATER

PUBLIC AREA
PAVEMENT CONNECTION + LIGHTING

Diagram: exploded axonometric

Diagram: urban context

167

The design concept for the New Dance and Music Centre in The Hague is developed from the unique urban dynamics of the site, resulting in a structure with subtle volumetric gestures that invite the public from the ground-level plaza into the heart of the building. The seamless continuation of the public domain into the structure further reinforces the cohesive character of the building, which combines four major institutions into one single envelope: the Royal Conservatory, the Netherlands Dance Theatre, the Residential Orchestra and the centre's Guest Programming. The building culminates in a gracious curving roofline that neatly nests itself within the city skyline.

In sharp contrast with basic rectangular geometry, the design features a fluid force field of horizontal louvers that seemingly moves when graced by light and shadow. This unique characteristic creates a playful language on the facade, articulating public circulation, the foyers and the sculpted inner atrium, while allowing visual connections outside to the square as well as exciting glimpses into the building.

デン・ハーグの新ダンス／ミュージック・センターのデザインは，敷地周辺の特異な都市の活力によって生み出された。控えめなヴォリューム表現により，地上レベルの広場から建物の中心にまで人を招き入れるような空間構成を得た。連続するシームレスなパブリック空間をつくることで，建物の一貫した表情を保つことができ，一つの建物の中に四つの主要機関を内包することが可能となった。それら機関とは，王立音楽学校，ネザーランド・ダンス・シアター，レジデンシャル・オーケストラおよびゲスト・プログラミングである。建物を完結する弧を描く屋根は街のスカイラインとうまく調和している。

単純な長方形とは対照的に，このデザインは光や影で彩られると蠢いて見える水平ルーバーが流線形の面をつくる。この特徴的な性質はファサードを多彩に演出し，パブリックの動線，ホワイエや彫刻的な内部アトリウムを統合し，また外部を広場および建物内の活気溢れる場面へと繋げている。

Diagram: Residential Orchestra

Diagram: Royal Conservatory

Diagram: Guest Programming

Diagram: Netherlands Dance Theater

Diagram: music education

Diagram: halls

169

Burnham Pavilion

2009 Chicago, U.S.A. Photos: Roland Halbe (except as noted)

Zaha Hadid Architects' pavilion design for Chicago's Burnham Plan Centennial celebrates the city's ongoing tradition of bold plans and big dreams. The project encourages reinvention and improvement on an urban scale and welcomes the future with innovative ideas and technologies whilst referencing the original organizational systems of Burnham's plan. Our design continues Chicago's renowned tradition of cutting edge architecture and engineering, at the scale of a temporary pavilion.

The design merges new formal concepts with the memory of bold historic urban planning. Superimpositions of spatial structures with hidden traces of Burnham's organizational systems and architectural representations create unexpected results. By using methods of overlaying, complexity is built up and inscribed in the structure.

The pavilion is composed of an intricate bent-aluminum structure, with each element shaped and welded in order to create its unique curvilinear form. Outer and inner fabric skins are wrapped tightly around the metal frame to create the fluid shape. The skins also serve as the screen for video installations to take place within the pavilion.

Zaha Hadid Architects' pavilion also works within the larger framework of the Centennial celebrations' commitment to deliberate the future of cities. The presence of the new structure triggers the visitor's intellectual curiosity whilst an intensification of public life around and within the pavilion supports the idea of public discourse.

The pavilion was designed and built to maximize the recycling and re-use of the materials after its role in Millennium Park. It can be re-installed for future use at another site.

Diagram: wireframe

North elevation

South elevation

East elevation

South elevation

West elevation

171

© Thomas Gray

ダニエル・バーナムの「The Plan of Chicago」誕生百年祭のためのパヴィリオンは，野心的な計画，そして偉大なる夢というシカゴに脈々と受け継がれる伝統を賛美するものである。このプロジェクトは都市像の再構築および改善を狙っており，当初のバーナムの計画における構成システムを壊すことのない，革新的なアイディアや技術でつくられる未来を迎え入れる。我々のデザインは，仮設パヴィリオンというスケールで，最新の建築と工学で知られるシカゴの伝統を体現している。

このデザインは，新しい形態コンセプトと野心的で歴史的な都市計画を溶け込ませている。空間構造と隠されたバーナムの構成システムや建築イメージを対比させることで，思いもよらない結果を生み出した。重層的な手法を用いることで複雑性が構築され建物の構成の中に組み込まれた。

パヴィリオンは複雑に湾曲したアルミニウム構造によって構成されており，特徴豊かな曲線的なフォルムとなるように，それぞれの

Roof

Section A

Section B

Plan

Section C

Section D

部材が形成され溶接されている。内外に用いられたファブリックは，流線形を出すために鉄のフレームにしっかりと蒔き付けられている。ファブリックはパヴィリオン内で行われるビデオのインスタレーション用のスクリーンとなる。

このパヴィリオンは都市の未来像を描くという誕生百年祭の大きな使命も果たしている。新しい構成の出現は訪問者の知的好奇心を誘い，パヴィリオン内外における公共性を高めることは，公共の対話（パブリック・ディスコース）を支持している。

ミレニアム・パークにおける任務終了後，パヴィリオンのマテリアルはリサイクルおよびリユースが出来るように配慮されている。他の場所で再度組み立てる事も可能である。

Exhibition 'Zaha Hadid and Suprematism'

2010 Gmurzynska Gallery, Zurich, Switzerland Photos: Martin Ruestchi

Diagram: wireframe perspective

Ground floor

Walls and floor graphic showing obstructions

Galerie Gmurzynska presents a seminal exhibition curated and designed by Zaha Hadid juxtaposing works of the Russian Avant-Garde with the work of Zaha Hadid Architects. A bright explosion of Russian Works pierces through the contemporary works of Zaha Hadid in a dynamic black and white design. The dialogue of these works constantly shifts and realigns as one moves through the space focusing on four themes: Abstraction, Distortion, Fragmentation, and Floatation.

A site specific artwork, the exhibition design is a projection of a 2-dimensional drawing into the 3-dimensional space. The gallery has become a spatial painting in which the threshold of the picture plane has expanded and can be entered.

It is a well established fact that the work of Zaha Hadid took its first inspiration from the early Russian avant-garde, in particular she directly engaged with the work of Kasimir Malevich. Malevich stands here for the enormously momentous discovery of abstraction as a heuristic principle that can propel creative work to hitherto unheard of levels of invention. Mimesis was finally abandoned and unfettered creativity could pour out across the infinitely receptive blank canvas. Space, or even better the world itself, soon became the site of pure, unprejudiced invention.

Hadid's work translated the warped and anti-gravitational space of Russian avant-garde painting and sculpture of Kasimir Malevitch, El Lissitzky and Alexander Rodchenko into her own unique architectural language. New exhibited work by Zaha Hadid Architects includes the Great Utopia Clusters; Victoria City Wire Frame sculpture; Negative and Positive Perspective Reliefs; Zephyr Sofa; Lunar Triptych Relief, and Fireplace.

ギャラリー・グムジンスカでは，ザハ・ハディドのキュレーションと構成による非常に独創的な展示が，41回目を迎えるアート・バーゼルに合わせて行われた。これはロシア・アヴァンギャルドの作品と，建築家の作品とを併置するものである。躍動的なモノクロームの構成は，現代的なザハ・ハディドの作品を貫くロシア・アヴァンギャルドの作品の眩い爆発によるものである。これらの作品同士の対話は，抽象，歪み，断片，浮遊といった四つのテーマに沿ってこの空間を移動するのに従って絶えず変化し，再編成される。

ここでは平面ドローイングを三次元空間へと投射する会場構成こそが，ひとつのサイト・スペシフィックな作品になっている。ギャラリーは立体絵画として，平面絵画の臨界点を越えて空間を内包している。

ハディドの初期の作品が，初期ロシア・アヴァンギャルド，とりわけ自身が深く傾倒していたカジミール・マレーヴィチの作品の影響を受けていることは非常によく知られた事実である。ここでマレーヴィチが象徴しているのは，創作活動をそれまでは未開であった新しい地平へと促す経験的法則として，抽象という非常に重要な概念を発見したことである。そこではミメーシスは最終的に放棄され，無限の包容力を持った空のキャンバスに，束縛されることのない創造力が満ち溢れている。空間が，あるいはこの世界自体と言ってもよいが，直ぐに純粋で先入観の無い創造の場となったのである。

ハディドの作品は，カジミール・マレーヴィチ，エル・リシツキー，あるいはアレキサンダー・ロドチェンコといったロシア・アヴァンギャルドによる曲がりくねって反重力的な絵画や彫刻作品に対する，ハディドの独創的な建築言語による再解釈である。建築家の新しい展示作品に含まれるのは，「グレート・ユートピア・クラスター」，「ヴィクトリア・シティ・ワイヤーフレーム」，「ネガティブ・ポジティブ・パースペクティブ」，「ゼファー・ソファ」「ルナ三部作」および「暖炉」である。

PROFILE

ZAHA HADID

Born in Baghdad, Iraq in 1950.

She attended American University of Beirut (Bachelor of Mathematics) in 1971 and studied architecture at Architectural Association, London from 1972 to 1977. She was awarded Diploma Prize in 1977.

She became a partner of OMA/Office for Metropolitan Architecture in 1977 and taught at AA with OMA collaborators Rem Koolhaas and Elia Zenghelis, and later led her own studio at AA until 1987. She has held Kenzo Tange Chair at Graduate School of Design, Harvard University; Sullivan Chair at University of Illinois, School of Architecture, Chicago; and guest professorships at Hochschule für Bildende Künste in Hamburg and Masters Studio at Columbia University, New York. She was also Eero Saarinen Visiting Professor of Architectural Design at Yale University, New Haven, Connecticut. Currently she is Professor at University of Applied Arts in Vienna, Austria.

She established private practice in London in 1980 and received Pritzker Architecture Prize in 2004. She is currently principal of Zaha Hadid Architects, London.

PATRIK SCHUMACHER

Born in Bonn, Germany in 1961.

He joined Zaha Hadid Architects in 1988. He is a partner and senior designer of the practice, as well co-author of a series of major projects.

He studied architecture at University of Stuttgart and at Southbank University in London. Completed architectural diploma and received degree Dipl.Ing. from Stuttgart University in 1990. He also studied philosophy in Bonn and London. In 1999 he received doctoral degree Dr. Phil. at Institute for Cultural Sciences at University of Klagenfurt.

In 1996 he co-founded "Design Research Laboratory" at Architectural Association. He has taught a series of post-graduate option studios with Zaha Hadid at University of Illinois, Columbia University and at Graduate School of Design at Harvard University. Currently, he is a tenured Professor at Institute for Experimental Architecture, Innsbruck University and guest professor at University of Applied Arts in Vienna.

LIST OF PROJECTS

01
MAXXI: NATIONAL MUSEUM OF XXI CENTURY ARTS
(1998-2010 Rome, Italy)
Architects: Zaha Hadid Architects—
Zaha Hadid with Patrik Schumacher, design;
Gianluca Racana, project architect;
Paolo Matteuzzi, Anja Simons, Mario Mattia, site supervision team; Anja Simons, Paolo Matteuzzi, Fabio Ceci, Mario Mattia, Maurizio Meossi, Paolo Zilli, Luca Peralta, Maria Velceva, Matteo Grimaldi, Ana M. Cajiao, Barbara Pfenningstorff, Dillon Lin, Kenneth Bostock, Raza Zahid, Lars Teichmann, Adriano De Gioannis, Amin Taha, Caroline Voet, Gianluca Ruggeri, Luca Segarelli, project team; Ali Mangera, Oliver Domeisen, Christos Passas, Sonia Villaseca, Jee-Eun Lee, James Lim, Julia Hansel, Sara Klomps, Shumon Basar, Bergendy Cooke, Jorge Ortega, Stephane Hof, Marcus Dochantschi, Woody Yao, Graham Modlen, Jim Heverin, Barbara Kuit, Ana Sotrel, Hemendra Kothari, Zahira El Nazel, Florian Migsch, Kathy Wright, Jin Wananabe, Helmut Kinzer, Thomas Knuvener, Sara Kamalvan, competition team
Planning consultant: ABT srl (Rome)
Client: Italian Ministry of Culture (Rome, Italy), Fondazione MAXXI
Consultants: Anthony Hunt Associates (London), OK Design Group (Rome), Studio S.P.C. S.r.l. (Rome), structural; Max Fordham and Partners (London), OK Design Group (Rome), mechanical and electrical; Equation Lighting (London), lighting;
Paul Gilleron Acoustic (London), acoustics
General contractor: MAXXI 2006 Consortium—Italiana Costruzioni S.p.A. (Navarra Group), S.A.C. Società Appalti Costruzioni S.p.A. (Cerasi Group)
Program: contemporary art and architecture centre, temporary exhibition spaces
Structural system: in-situ reinforced concrete supporting walls connected by a series of transversal steel beams
Major materials: in-situ reinforced concrete walls; steel roof beams; glass reinforced concrete roof-light fins; painted steel staircase
Site area: 29,000 m^2
Footprint area: approx. 6,000 m^2
Total floor area: 21,200 m^2, interior; 19,640 m^2, exterior

02
SHEIKH ZAYED BRIDGE
(1997-2010 Abu Dhabi, United Arab Emirates)
Architects: Zaha Hadid Architects—
Zaha Hadid, design; Graham Modlen, project architect;
Garin O'Aivazian, Zahira Nazer, Christos Passas, Sara Klomps, Steve Power, project team;
Highpoint Rendel, project engineer
Client: Abu Dhabi Municipality
Consultants: Rendel Palmer Tritton (London), structural; Hollands Licht (Amsterdam), lighting
General contractor: Six Construct (contract number 3)
Program: 2 ways four lane highway bridge to Abu Dhabi Island
Structural system: reinforced concrete roadway deck sections supported from in-situ concrete piers and steel arches
Major materials: piers and decking in reinforced concrete, steel arches
Total floor area: 51,362 m^2
Size: 842 m long, 64 m high, 61 m wide

03
GLASGOW RIVERSIDE MUSEUM
(2004-11 Glasgow, Scotland, U.K.)
Architects: Zaha Hadid Architects—
Jim Heverin, project director;
Johannes Hoffmann, project architect;
Matthias Frei, Agnes Koltay, Malca Mizrahi, Tyen Masten, Gemma Douglas, Johannes Hoffmann, Daniel Baerlaecken, Achim Gergen, Christina Beaumont, Markus Planteu, Claudia Wulf, Alasdair Graham, Rebecca Haines-Gadd, Brandon Buck, Naomi Fritz, Liat Muller, Elke Presser, Hinki Kwon, Michael Mader, Ming Cheong, Mikel Bennett, Jieun Lee, Chun Chiu, Aris Giorgiadis, Lole Mate, Thomas Hale, Andreas Helgesson, Andy Summers, Des Fagan, Laymon Thaung, Electra Mikelides, project team;
Malca Mizrahi, Michele Pasca di Magliano, Viviana R. Muscettola, Mariana Ibanez, Larissa Henke, competition team
Client: Glasgow City Council
Consultants: Buro Happold (Glasgow), services;
Buro Happold (Bath), acoustics; FEDRA (Glasgow), fire safety; Capita Symonds, cost consultants and project management
Program: exhibition space, cafe, retail, education
Structural system: steel frame
Major materials: corrugated metal decking and zinc cladding, glass reinforced gypsum interior surfaces
Site area: 22,400 m^2
Footprint area: 7,800 m^2
Total floor area: 11,000 m^2 (exhibition area 7,000 m^2)

04
CMA CGM TOWER
(2006-10 Marseille, France)
Architects: Zaha Hadid Architects—
Jim Heverin, project director;
Stephane Vallotton, project architect;
Karim Muallem, Simone Contasta, Andres Flores, Pedja Pantovic, Alvin Triestanto, Jerome Michel, Leonie Heinrich, Marian Ripoll, Bushan Mantri, Muriel Boselli, Eugene Leung, Prashanth Sridharan, Birgit Eistert, Nerea Feliz, Evelyn Gono, project team;
Jim Heverin, Simon Kim, Michele Pasca Di Magliano, Viviana Muscettola, competition team
Associate architect: SRA Paris
Partner architect: SRA–RTA (Paris/Marseille)
Client: CMA CGM
Consultants: Ove Arup & Partners (London), structural, services; Ove Arup & Partners/Robert-Jan Van Santen Associates (London/Lille), facade engineers;
R2M (Marseille), cost consultant
Program: head offices and parking
Structural system: reinforced in-situ concrete frame
Major materials: reinforced concrete, fully glazed unitized facade
Site area: 8,400 m^2
Footprint area: 6,000 m^2
Total floor area: 94,000 m^2 (58,000 m^2, tower; 36,000 m^2, annex building)
Size: 142.8 m high (33 floors)

05
LONDON AQUATICS CENTRE
(2005-11 London, U.K.)
Architects: Zaha Hadid Architects—
Jim Heverin, project director;
Glenn Moorley, Sara Klomps, project architects;
Alex Bilton, Alex Marcoulides, Barbara Bochnak, Carlos Garijo, Clay Shorthall, Ertu Erbay, George King, Giorgia Cannici, Hannes Schafelner, Hee Seung Lee, Kasia Townend, Nannette Jackowski, Nicolas Gdalewitch, Seth Handley, Thomas Soo, Tom Locke, Torsten Broeder, Tristan Job, Yamac Korfali, Yeena Yoon, project team;
Saffet Kaya Bekiroglu, project architect (competition);
Agnes Koltay, Feng Chen, Gemma Douglas, Kakakrai Suthadarat, Karim Muallem, Marco Vanucci, Mariana Ibanez, Sujit Nair, project team (competition)
Client: Olympic Delivery Authority
Consultants: S+P Architects (London), sports architects; Ove Arup & Partners (London, Newcastle), structural; Ove Arup & Partners (London), services, BREEAM consultant; Arup Fire (London), fire safety; Arup Acoustics (London), acoustics; Robert-Jan Van Santen Associates (Lille), facade engineers; Arup Lighting (London), lighting; Winton Nightingale (London), kitchen design;
Reef (London), maintenance access;
Edwin Shirley Staging (London), temporary construction;
Arup Security (London), security consultant;
Mark Johnson Consultants (London), AV + IT consultants;
Access = Design (London), access consultant;
Total CDM Solutions (Cardigan), CDM co-coordinator
Program: aquatics centre for 2012 Summer Olympics and future use
Site area: 36,875 m^2
Footprint area: 15,950 m^2, Legacy mode;
21,897 m^2, Olympic mode
Floor area: Legacy mode—3,725 m^2 (basement), 15,137 m^2 (ground floor), 10,168 m^2 (first floor);
Olympic mode—3,725 m^2 (basement), 15,402 m^2 (ground floor), 16,387 m^2 (first floor), 7,352 m^2 (seating area)

06
MIDDLE EAST CENTRE, ST. ANTONY'S COLLEGE
(2006- Oxford, U.K.)
Architects: Zaha Hadid Architects—
Jim Heverin, associate director;
Kenneth Bostock, project architect;
Goswin Rothenthal, Theodora Ntatsopoulou, Saleem Abdil, Mireia Sala Font, Amita Kulkarni, design team
Client: Middle East Centre, St. Antony's College, University of Oxford
Consultants: Adams Kara Taylor, structural; Max Fordham, mechanical, electrical and acoustics; Arup Lighting, lighting; Arup Facade Engineering, facade engineering;
Sense Cost Ltd., cost consultant; Arup Fire, fire engineer; JPPC Oxford, planning supervision; Sarah Venner, forestry and arboriculture consultant; David Bonnet, access;
Gross Max, landscape; Andrew Goddard Associates, CDM (construction, design & management regulations consultant); Cityscape, visualisation
Program: new academic building
Site area (built area): 900 m^2
Total floor area: 1,200 m^2

07
HEYDAR ALIYEV CULTURAL CENTRE
(2007- Baku, Azerbaijan)
Architects: Zaha Hadid Architects—
Zaha Hadid with Patrik Schumacher, design;
Saffet Kaya Bekiroglu, project architect;
Sara Sheikh Akbari, Deniz Manisali, Marc Boles, Shiqi Li, Phil Soo Kim, Yelda Gin, Liat Muller, Lillie Liu, Jose Lemos, Jose Ramon Tramoyeres, Simone Fuchs, Yu Du, Josef Glas, Michael Grau, Erhan Patat, Deepti Zachariah, Fadi Mansour, Jaime Bartolome, Tahmina Parvin, Ceyhun Baskin, Daniel Widrig, Helen Lee, Murat Mutlu, project team
Local architect: DIA
Client: The Republic of Azerbaijan
Consultants: AKT, Tuncel Engineers, structural;
Mero, space frame; Werner Sobek, facade consultant;
GMD Engineers, mechanical; DBKes, acoustics; MBLD, lighting; Etik Engineering, fire consultant; BME Ltd. Co., people movers
Program: mixed-use cultural centre
Site area: 111,292 m^2 (inside property line)
Footprint area: 15,514 m^2 (ground floor to exterior skin)
Total floor area: 101,801 m^2

08
MUSEUM IN VILNIUS
(2007- Vilnius, Lithuania)
Architects: Zaha Hadid Architects—
Zaha Hadid with Patrik Schumacher, design;
Thomas Vietzke and Jens Borstelmann, project architects;
Kristof Crolla, Julian Breinersdorfer, Melodie Leung, Claudia Wulf, David Seeland, project team
Client: City of Vilnius, Lithuania
Consultants: AKT, structural; Max Fordham, mechanical and electrical; SENSE, cost consultant; Checkpointmedia Multimediaproduktionen, media concept; Anne Minors Performance Consultants, theatre consultant
Program: museum, cultural centre
Site area: 98,500 m^2
Footprint area: 7,800 m^2
Total floor area: 13,000 m^2

09
REGIUM WATERFRONT
(2007- Reggio Calabria, Italy)
Architects: Zaha Hadid Architects—
Zaha Hadid with Patrik Schumacher, design;
Filippo Innocenti, project architect;
Michele Salvi, Roberto Vangeli, Andrea Balducci Castè, Luciano Letteriello, Fabio Forconi, Giuseppe Morando, Johannes Weikert, Deepti Zachariah, Gonzalo Carbajo, project team (competition)
Client: Comune di Reggio Calabria
Consultants: Adams-Kara-Taylor—Hanif Kara, structural;
Max Fordham—Neil Smith, mechanical and electrical;
Macchiaroli & Partners, fire safety; Building Consulting—Alba de Pascale, Edoardo Lima, cost surveyor;
Studio Prima—Pietro Chiavaccini, Maurizio Verzoni, maritime structures
Program: mixed-use (Museum of the mediterranean and Multifunctional block)
Site area: 61,360 m^2
Footprint area: approx. 8,375 m^2, Multifunctional Centre; approx. 13,000 m^2, Museum
Total floor area: approx. 19,800 m^2, Multifunctional Centre; approx. 12,600 m^2, Museum

10
NEW BEETHOVEN CONCERT HALL
(2008-09 Bonn, Germany)
Architects: Zaha Hadid Architects—
Zaha Hadid with Patrik Schumacher, design;
Thomas Vietzke and Jens Borstelmann, project architects;
Kristof Crolla, Tom Wuenschmann, Evan Erlebacher,
Andres Schenker, Chryssanthi Perpatidou,
Elizabeth Bishop, Michael Powers, Teoman N. Ayas,
Michael Mader, Goswin Rosenthal, Tariq Khayyat,
Yelda Gin, project team
Client: Deutsche Post AG, Deutsche Telekom,
Deutsche Postbank
Consultants: Bollinger & Grohmann (Frankfurt), structural and facade consultant; Arup (London), acoustics and venue consultant; Arup (Berlin), mechanical and electrical; SENSE (London), cost consultant; Brandi (Hamburg), lighting; Aldo Ceccato (Milan), orchestra consultant
Program: symphony hall, chamber music hall/recital hall
Site area: 37,000 m^2
Footprint area: 4,600 m^2
Total floor area: 12,800 m^2

11
KING ABDULLAH II HOUSE OF CULTURE & ART
(2008- Amman, Jordan)
Architects: Zaha Hadid Architects—
Zaha Hadid and Patrik Schumacher, design;
Charles Walker, project director; Tariq Khayyat, project architect; Jalal El-Ali, Matteo Melioli, Eren Ciraci, Diego Rossel, Akif Cinar, project team; Maria Araya, Melike Altinisik, Dominiki Dadatsi, Renata Dantas, Sylvia Georgiadou, Britta Knobel, Rashiq Muhamadali, Bence Pap, Eleni Pavlidou, Daniel Santos, Daniel Widrig, Sevil Yazici, competition team
Client: The Greater Amman Municipality
Consultants: Dar Al-Handasah, Beirut-Cairo, structural, mechanical and electrical; Artec Consultants Inc. (New York), theatre & acoustics; Ramboll (London), facade engineers; Office for Visual Interaction Inc. (New York), lighting
Program: concert theatre (1,600-seat), small theatre (400-seat), educational centre and galleries
Site area: 32,371 m^2
Footprint area: 5,363 m^2
Total floor area: 26,800 m^2

12
STONE TOWERS
(2008- Cairo, Egypt)
Architects: Zaha Hadid Architects—
Zaha Hadid and Patrik Schumacher, design;
Chris Lépine, project director; Tyen Masten, project architect; Celina Auterio, Alessio Costantino, Matthew Engele, Elke Frotscher, Brandon Gehrke, Evelyn Gono, Subharthi Guha, Sofia Hagen, Josias Hamid, Michael Hargens, Michael Harris, Verena Hoch, Ben Kikkawa, Kay Kulinna, Michael Mader, Sang Hoon Oh, Irene Pabustan, Chryssanthi Perpatidou, Fernando Poucell, Irena Predalic, Mahmoud Riad, Timothy Schreiber, Eva Tiedemann, Leo Wu, Michelle Wu, AnasYounes, Ceyhun Baskin, David Campos, Eren Ciraci, Inanc Eray, Jose Lemos, Daniel Norell, Azen Omar, Edgar Payan, Sofia Razzaque, Ebru Simsek, project team
Local architect: Okoplan Architecture and Concept
Client: Rooya Group
Consultants: Adams Kara Taylor, Okoplan Structure (Cairo), structural; Hoare Lea, mechanical, electrical and specialist engineering; ICG/Integrated Consultant Group, mechanical, electrical; Newtecnic, facade consultant; Gross Max, landscape; SEAM, lighting; Space Agency, wayfinding; Davis Langdon, cost consultant
Program: mixed-use buildings (office, retail, hotel)
Site area: 179,970 m^2
Footprint area: approx. 179,970 m^2
Floor area: 20,813 m^2, retail; 226,163 m^2, North Office Buildings; 231,134 m^2, South Office Buildings; 85,500 m^2, hotel

13
CASART
(2009 Casablanca, Morocco)
Architects: Zaha Hadid Architects—
Zaha Hadid with Patrik Schumacher, design;
Nils-Peter Fischer, project director;
Ting Ting Zhang, project architect;
Thomas Frings, William Tan, Maren Klasing, Martin Krcha, Leo Wu, Johannes Elias, Torsten Broeder, Naomi Chen, Aditya Chandra, Hoda Nobakhti, project team
Local architect: Omar Alaoui Architectes (Casablanca)
Client: City of Casablanca & Fondation des Art Vivants
Consultants: AdamsKaraTaylor (London), structural; Max Fordham (London), mechanical and electrical; Artec Consultants (New York), acoustics; GrossMax (Edinburgh), landscape; Office for Visual Interaction /OVI (New York), lighting; Savell, Bird, Axon (London), traffic and logistics; WT Partnership (London), quantity surveyor
Program: opera house and theatre complex with restaurants, event spaces; additional plaza redesign with integrated carpark
Site area: 90,000 m^2 (including plaza)
Footprint area: 16,000 m^2
Total floor area: 34,970 m^2
Size: 35 m high

14
SUNRISE TOWER
(2009 Kuala Lumpur, Malaysia)
Architects: Zaha Hadid Architects—
Zaha Hadid and Patrik Schumacher, design;
Tiago Correia, project director; Victor Orive, Fabiano Continanza, project architects;
Alejandro Diaz, Rafael Gonzalez, Monica Noguero, Oihane Santiuste, Maren Klasing, Martin Krcha, Daniel Domingo, project team
Local architect: Veritas Design Group
Client: Sunrise Berhad
Consultants: Buro Happold, engineering; JUBM, cost consultant
Program: mixed-use tower (offices, commercial, hotel and residential)
Site area: 6,800 m^2
Footprint area: 2,800 m^2
Total floor area: 150,000 m^2 (21,000 m^2, offices; 6,000 m^2, commercial; 16,000 m^2, hotel; 64,000 m^2, residential; 43,000 m^2, parking)
Size: 280 m high

15
GUI RIVER CREATIVE ZONE
(2009 Beijing, China)
Architects: Zaha Hadid Architects—
Nils-Peter Fischer, project director;
Shajay Bhooshan, project architect;
Yu Du, Suryansh Chandra, Shao-Wei Huang, Alexia Anastasopoulou, Ho-Ping Hsia, Johannes Elias, Hoda Nobakhti, project team
Client: People's Government of Yanqing County, Beijing Municipality
Consultants: Arup, infrastructure; Grossmax, landscape; Lawrence Barth, urban theory
Program: competition entry for a 210,000 m^2 site reserved for a mixed-use 'Creative District'
Site area: approx. 210,000 m^2
Floor area: 280,000 m^2, hotel; 40,000 m^2, education & training; 50,000 m^2, creative studio; 10,000 m^2, exhibition & exchange

16
THE CIRCLE AT ZURICH AIRPORT
(2009 Kloten, Switzerland)
Architects: Zaha Hadid Architects—
Zaha Hadid with Patrik Schumacher, design;
Manuela Gatto, project architect (design associate);
Dillon Lin, technical associate; Hannes Schafelner, Maren Klasing, Teoman Ayas, Lisamarie Ambia, Camiel Weijenberg, Seda Zirek, Ai Sato, Andres Madrid, Amit Gupta, Sophie Le Bienvenu, Rashiq Muhamadali, Roxana Rakshani, Nupur Shah, Fabian Hecker, Saleem A. Jalil, Daniel Piccinelli, project team
Local architect: Burkhardt + Partners AG
Client: Unique
Consultants: Adams Kara Taylor, structural; Woods Bagot, interior; ARUP Berlin, facade engineer; Baukostenplanung Ernst, cost consultant; Office for Visual Interaction, lighting; Amstein + Waltherт, fire consultant; Gross Max, landscape; Pragma UK, brand consultant
Program: mixed-use building (office, brand space, medical clinics, education facilities, hotel, spa, gym, restaurants, cafes)
Site area: 27,845 m^2
Footprint area: 33,170 m^2 (including bridge and upper levels)
Total floor area: 200,000 m^2

17
GALAXY SOHO
(2009-12 Beijing, China)
Architects: Zaha Hadid Architects—
Zaha Hadid with Patrik Schumacher, design;
Satoshi Ohashi, project director; Cristiano Ceccato, associate; Raymond Lau, project manager;
Yoshi Uchiyama, project architect;
Stephan Wurster, Michael Hill, Samer Chamoun, Eugene Leung, Rita Lee, Lillie Liu, Rolando Rodriguez-Leal, Wen Tao, Tom Wuenschmann, Seung-ho Yeo, Shuojiong Zhang, Michael Grau, Shu Hashimoto, Shao-Wei Huang, Chikara Inamura, Lydia Kim, Yasuko Kobayashi, Wang Lin, Yereem Park, project team
Client: SOHO China Ltd.
Program: commercial office & retail complex
Site area: 50,000 m^2
Total floor area: 330,000 m^2
Size: 67 m high (maximum height)

18
CAIRO EXPO CITY
(2009- Cairo, Egypt)
Architects: Zaha Hadid Architects—
Zaha Hadid with Patrik Schumacher, design;
Viviana Muscettola, Michele Pasca di Magliano, project directors; Kutbuddin Nadiadi, Effie Kuan, Loreto Flores, Hee Seung Lee, Alvin Triestanto, Pierre Forrisier, Philipp Ostermaier, Xia Chun, Victoria Goldestein, Shirley Hottier, Katrina Wong, Natalie Popik, Gerry Cruz, project team; Viviana Muscettola, Michele Pasca di Magliano, Charles Walker, Tariq Khayyat, Kutbuddin Nadiadi, Ludovico Lombardi, Effi e Kuan, Loreto Flores, Bianca Cheung, Dominiki Dadatsi, Feng Lin, Annarita Papeschi, Hee Seung Lee, Dawna Houchin, Monica Noguero, Rafael Contreras, Maria Araya, Fernando Poucell, David Campos, Seda Zirek, competition team
Client: GOIEF, Egypt
Consultants: Buro Happold (London), specialist engineering, structural, mechanical and electrical; Gardiner and Theobald (London), quantity surveyor; Theater Projects Consultants, theatre consultant; Office for Visual Interaction, lighting; GrossMax, landscape
Program: exhibition and conference centre
Site area: 395,651 m^2
Footprint area: 144,186 m^2 (132,586 m^2, exhibition center; 11,600 m^2, convention center)
Total floor area: 192,612 m^2 (154,162 m^2, exhibition center; 38,450 m^2, convention center)

19
WANGJING SOHO
(2009- Beijing, China)
Architects: Zaha Hadid Architects—
Zaha Hadid with Patrik Schumacher, design;
Satoshi Ohashi, project director; Cristiano Ceccato, associate; Raymond Lau, project manager;
Armando Solano, project architect;
Bianca Cheung, Yu Du, Ed Gaskin, Sally Harris, Chao-Ching Wang, Feng Lin, Yikai Lin, Oliver Malm, Rashiq Muhamadali, Matthew Richardson, Yichi Zhang, Yan Guangyuan, Ma Xinyue, Zhang Zhe, project team
Client: SOHO China Ltd.
Program: commercial office & retail complex
Site area: 115,393 m^2
Footprint area: 21,000 m^2
Total floor area: 521,265 m^2 (392,265 m^2, above grade; 129,000 m^2, below grade)
Size: 200 m high (maximum height)

20
KING ABDULLAH PETROLEUM STUDIES AND RESEARCH CENTRE
(2009- Riyadh, Saudi Arabia)
Architects: Zaha Hadid Architects—
Zaha Hadid with Patrik Schumacher, design;
Lars Teichmann, Charles Walker, project directors;
DaeWha Kang, design director;
Fabian Hecker, Michael Powers, Brian Dale, Henning Hansen, Fulvio Wirz, Elizabeth Bishop, Saleem A. Jalil, Maria Rodero, Lisamarie Ambia, Judith Wahle, Bozana Komljenovic, John Randle, John Szlachta, project leaders; Adrian Krezlik, Alexander Palacio, Amit Gupta, Annarita Papeschi, Ayca Vural Cutts, Britta Knobel, Camiel Weijenberg, Carine Posner, Claire Cahill, DaChun Lin, Daniel Fiser, David Seeland, Deniz Manisali, Elizabeth Keenan, Evan Erlebacher, Garin O'Aivazian, Giorgio Radojkovic, Inês Fontoura, Jeremy Tymms, Julian Jones, Jwalant Mahadevwala, Lauren Barclay, Lauren Mishkind, Malgorzata Kowalczyk, Mariagrazia Lanza, Melike Altinisik, Michael Grau, Michael McNamara, Michal Wojtkiewicz, Mimi Halova, Mohammed Reshdan, Monika Bilska, Muriel Boselli, MyungHo Lee, Nahed Jawad, Natacha Viveiros, Navvab Taylor, Pedro Sanchez, Prashanth Sridharan, Roxana Rakhshani, Saahil Parikh, Sara Criscenti, Sara Saleh, Shaju Nanukuttan, Shaun Farrell, Sophie Le Bienvenu, Stefan Brabetz, Steve Rea, Talenia Phua Gajardo, Yu Du, project team
Client: ARAMCO, Saudi Arabia
Consultants: Arup, engineering; Woods Bagot, interior; Gross Max, landscape; Office For Visual Interaction, lighting; Eastern Quay and GWP, catering and kitchen design; Event, exhibition design; Elmwood and Bright 3d, branding and signage; Tribal, library consultant; Davis Langdon, cost consultant and design project management
Program: masterplan and design for world-class research facility
Site area: 530,000 m^2
Footprint area: 28,500 m^2
Total floor area: 66,000 m^2

21
NEW DANCE AND MUSIC CENTRE, THE HAGUE
(2010- The Hague, The Netherlands)
Architects: Zaha Hadid Architects—
Zaha Hadid with Patrik Schumacher, design;
Joris Pauwels, project associate; Paulo Flores, project leader; Rafael Contreras, Yevgeniya Pozigun, Thomas Buseck, Oliver Malm, Hoda Nobakhti, Akif Cinar, project team
Local architect: Bureau Bouwkunde (The Netherlands)
Client: City of The Hague
Consultants: AKT (U.K.), structural; Max Fordham (U.K.), services; Theatre Projects Consultants (U.K.), theatre consultant; Newtecnic (U.K.), facade consultant; Peutz (The Netherlands), acoustics
Program: dance and music center
Site area: 6,000 m^2
Footprint area: 4,400
Total floor area: 48,000 m^2 (excluding underground car parking)

22
BURNHAM PAVILION
(2009 Chicago, U.S.A.)
Architects: Zaha Hadid Architects—
Zaha Hadid and Patrik Schumacher, design;
Jens Borstelmann, Thomas Vietzke, project architects;
Teoman Ayas, Evan Erlebacher, project team
Local architect: Thomas Roszak
Client: Burnham Plan Centennial
Consultants: Rockey Structures, structural; Fabric Images, fabricator; Tracey Dear, lighting and electrical
Multimedia content: Thomas Gray, The Gray Circle, film installation; Lou Mallozzi, Experimental Sound Studio, sound design
General contractor: Fabric Images (Elgin, Illinois, USA)
Program: temporary pavilion to house multimedia installation
Structural system: aluminium ribs
Major materials: aluminium ribs, fabric exterior
Site area: 500 m^2
Footprint area: 300 m^2
Total floor area: 120 m^2

23
EXHIBITION 'ZAHA HADID AND SUPREMATISM'
in Gmurzynska Gallery
(June–September, 2010 Zurich, Switzerland)
Architects: Zaha Hadid Architects—
Zaha Hadid and Patrik Schumacher, design/curation;
Woody K. T. Yao, project director; Melodie Leung, project architect; Maha Kutay, Manon Janssens, Filipa Gomes, Aram Gimbot, project team;
Antonio De Campos, artist consultant
Client: Galerie Gmurzynska
Galerie directors: Krystyna Gmurzynska and Mathias Rastorfer
Program: exhibition
Total floor area: 230 m^2

ZAHA HADID RECENT PROJECT
ザハ・ハディド 最新プロジェクト

2010年8月25日発行

企画：二川幸夫
撮影：GA photographers
印刷・製本：大日本印刷株式会社
制作・発行：エーディーエー・エディタ・トーキョー
151-0051　東京都渋谷区千駄ヶ谷3-12-14
TEL. (03) 3403-1581 (代)

禁無断転載
ISBN 978-4-87140-669-7 C1052